iPHONE
PHOTOGRAPHY

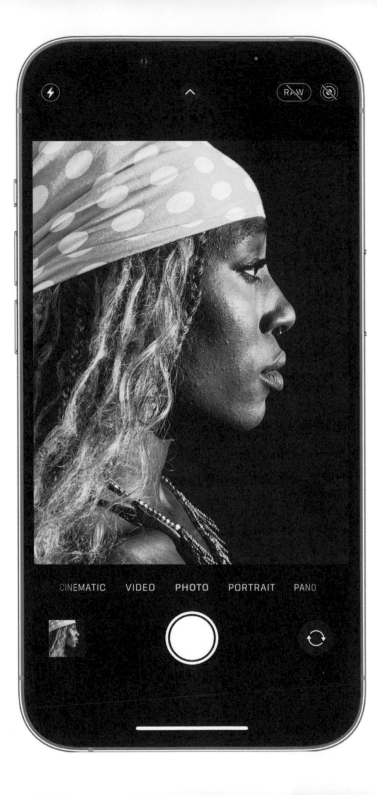

iPHONE
PHOTOGRAPHY

JACK HOLLINGSWORTH

AMMONITE
PRESS

ASSIGNMENTS

Tick off your completed projects

ASSIGNMENT KEY

Each assignment has symbols showing the type of tasks involved.

 EDIT COMPOSITION TECHNIQUE

 SETTINGS CREATIVITY

INTRODUCTION

I took my first picture on an SLR back in 1975. Little did I know at the time how this innocent act of joy would change the trajectory of my life and end up as my career. Since that serendipitous moment, I have been lucky enough to run a successful photographic business while experiencing life through a lens.

It would be a severe understatement to say I like photography. I love photography. I'm obsessed with it. I am as impassioned and zealous about photography today as I was back in the mid-70s. It never gets tiresome or old.

What's even more amazing is that I am more emotionally attached to my work now than I have ever been in the past, and that's all down to my beloved iPhone® camera. I feel, I shoot, and I capture, edit, and share anything, anytime, anywhere.

Early in my photography journey, I had naively convinced myself that the way to really get better and improve my photography was to master the technical side—the buttons, dials, menus, knobs, settings, and so on of the camera I was using. But I've come to realize that this is only part of the challenge; what is more important is knowing how to stay motivated and be inspired to take photos. Most photographers don't really need much more information on *how* to take a photograph; instead, what they need is inspiration about *what* to photograph to keep them focused, absorbed, and engrossed.

Remarkable and memorable photography is born through a seamless combination and assimilation of technology, technique, tools, temperament, training, and timing, along with tireless, indefatigable, rinse-and-repeat experimentation in what you are shooting.

To this end, I give you 52 assignments that I hope will inspire you as well as provide you with the tips and techniques that I've learned over my career. I hope they serve your photographic wants, wishes, and needs, as they have my own.

I wish you the best of luck in taking the most creative and rewarding photos of your life with the world's most popular camera.

Jack Hollingsworth

TIPS

- In post-processing, it is far easier to recover detail from an underexposed, darker, or shadowy area of your photo than recover detail in an overexposed or blown-out part of an image.

- The iPhone in Auto tends to slightly overexpose many subjects. So even when I shoot in Auto mode, I tend to use the Brightness slider to moderately underexpose or darken my photos, either during or after capture.

- Conventional camera users often talk about "exposing to the right," meaning they slightly overexpose their photos, but they only apply a small amount of overexposure as highlights that are blown to white can't be recovered.

▶ *In my experience, Auto is going to work about eighty percent of the time. So you should be fine if you decide to never go past Auto, but trust me, hidden in that mysterious twenty percent beyond it are great possibilities.*

BEYOND AUTOMATIC

When you open up the iPhone Camera app, it is set by default to Automatic. In other words, the camera app sets your focus, as well as the exposure points and values. This makes it possible to capture great photos, anytime, anywhere. But as smart as the iPhone camera app is, it doesn't know what your creative intentions are for a particular photograph. It might be that you want the point of focus to be somewhere other than dead center in the frame. Or you may prefer a brighter or darker exposure than what the camera app selects for you. The simple, surefire solution is this: "Tap to focus, drag to expose." Instead of always relying on the iPhone camera app to automatically set the focus and exposure points in your photograph, you manually or semi-manually do the same.

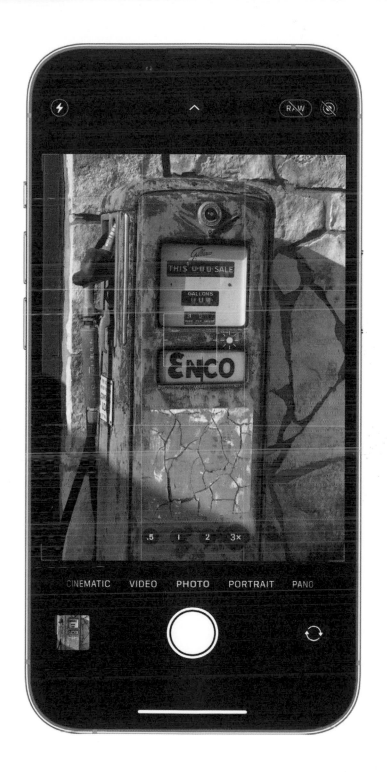

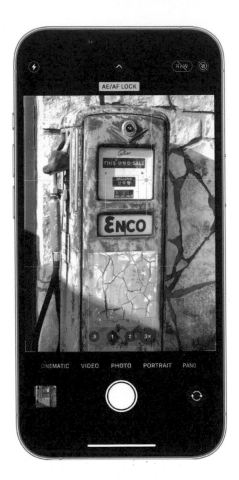

There really is no such thing as a perfect exposure. For certain subjects, scenes, and scenarios that include predominantly light tones, the iPhone's camera is going to give you an exposure that appears a little darker than what your eyes see. In this case, you will want to drag your Brightness slider upward for a lighter exposure. For other subjects that include predominantly dark tones, the iPhone's camera is going to give you an exposure that feels slightly lighter than what your eyes see. In this case, you will want to drag the Brightness slider downward for a darker exposure.

For this assignment, you'll take three photos of the same scene to see how much difference working in manual makes, and how straightforward it is to do it. First, take a photograph in Auto and see if you like the focus and exposure levels that the camera app, under the hood, sets for you. Next, take a second photo, tapping on where in the scene you want to focus on, then drag the Brightness slider up for a more illuminated and airy capture. Finally, take a third photo in the same way, but this time, drag the Brightness slider down for a darker and more moody capture.

▲ *I don't overexpose my images because the iPhone tends to overexpose them anyway. Instead, I tweak the exposure with the Exposure or Brightness sliders in the Photos app either during capture or when editing.*

THE PROCESS

1 Tap the object or person on your screen you want to focus on. This allows you to manually set your focus point.

2 Once you have your focus point selected, you will see a yellow box on the same spot with a sun icon next to it. This is your Brightness slider. Dragging the slider up will brighten the image, while dragging the slider down will darken your photograph. You are effectively using the slider to manually set your exposure value.

ASSIGNMENT

02

TIPS

- Under normal circumstances, traditional cameras, especially those with full-frame sensors, produce a wider dynamic range, with more subtle tones and gradations, than smartphone cameras, which have considerably smaller sensors.

- What iPhone cameras lack due to hardware (small sensors), they gain in software (Deep Fusion™ image processing system, Night mode, Photographic Styles, Portrait mode, Smart HDR, Cinematic mode), rendering very pleasing and wide dynamic ranges that rival dedicated cameras.

- It is far easier to keep the dynamic range of a subject or scene within the limiting scope of the dynamic range of an iPhone camera sensor when under cloud cover, rather than in bright, contrasty light.

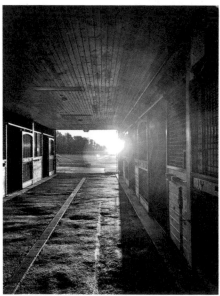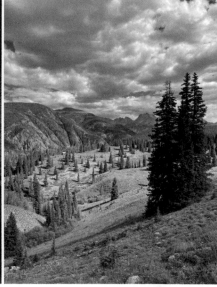

COME WITHIN RANGE

Every scene you point your camera at has a certain dynamic range, which is the range of tonal light intensities from the darkest shadows to the brightest highlights. A silhouette of a person at sunset would have a wide dynamic range, meaning that there are significant tonal and exposure differences between the darkest and lightest areas of the photographs. Fortunately for photographers, most scenes have a much narrower and more manageable dynamic range.

In photography speak, dynamic range can be measured and described in Exposure Value (EV) or "stops." Each stop equals double or half the amount of light. To complicate matters even further, camera sensors have their own dynamic range. If the dynamic range of the scene you are photographing exceeds the dynamic range of the camera sensor, you'll end up with a photograph where either the shadows are completely black and blocked up (underexposed) or where the highlights have "blown out" and become totally white and devoid of any detail (overexposed).

Okay, let's get practical. Go shoot an outside scene that includes both a bright sky and areas with shadows. Look closely at the photograph; are you seeing detail in the sky or is it white and blown out? Are you seeing detail in the shaded area, or does it look muddy or even black? This is dynamic range in action. When the dynamic range of a scene exceeds the dynamic range of your sensor, you must decide whether the detail in the sky or in the areas in shadow is most important.

◀ The iPhone will handle the dynamic range remarkably well for most outdoor scenes without you having to do anything extra. However, when you include the sun in the frame, the dynamic range of the scene is extended significantly beyond what the sensor can accommodate. In this situation, you have to determine whether you want to expose for the highlights or the shadows.

PRO TIP

Typical dynamic ranges include:

• **24 stops**: average technical dynamic range of the human eye.*

• **14–15 stops**: average discernible dynamic range of the human eye.

• **12–15 stops**: average dynamic range of full-frame DSLRs.

• **8–12 stops**: average dynamic range of iPhone cameras.

* The human eye focuses on areas with different dynamic ranges to create a higher total dynamic range.

ASSIGNMENT

03

TIPS

- Image orientation is the practical choice a photographer makes to determine whether a photograph is wider or taller. Horizontal or Landscape mode produces a photo with the long sides of the rectangle at the top and bottom. Vertical or Portrait mode is a photo where the long sides of the rectangle are on the left and right sides.

- Aspect ratio is the relationship between the width and height of an image. The 4:3 aspect ratio is by far the most common for phone camera sensors. A horizontal image is a 4:3 aspect ratio—four units wide, three units high. A vertical image is a 3:4 aspect ratio—three units wide, four units high.

- For the lion's share of my "big camera" career, I shot predominately in horizontal mode, quite often to accommodate magazine spreads for editorial usage. Since exclusively shooting with phone cameras, my main image orientation is vertical.

ORIENTATE YOURSELF

In photographic circles, image orientation refers to the way our photographs are taken and displayed. When held normally, traditional cameras will take a landscape shot, and so the vast majority of photos are in a horizontal orientation. In contrast, phone cameras held normally in one hand will take a portrait shot, and so smartphone photography and video are increasingly shot or cropped in a vertical orientation. Human vision is primarily horizontal in nature, and so are most of the TV and computer screens we use to display our media, including photography. But that doesn't mean we should only, or even mostly, shoot in horizontal orientation. There are many situations in photography where it is better to shoot vertically rather than horizontally.

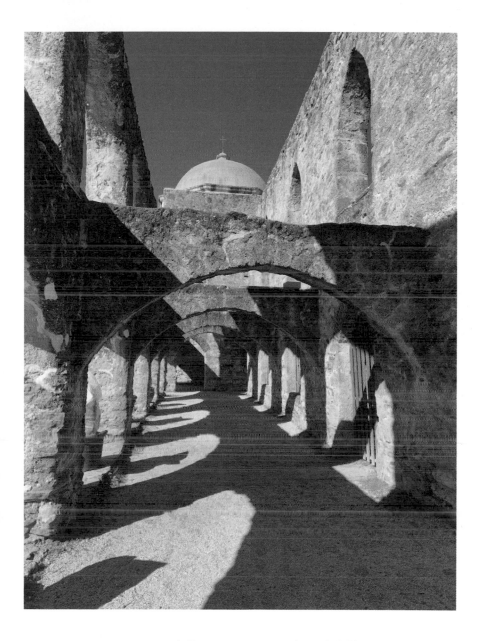

▲ *Because so many people use their iPhone to take photos they intend to share on social media, a vertical orientation is now more popular than horizontal—I would estimate that ninety percent of the shots I take are vertical.*

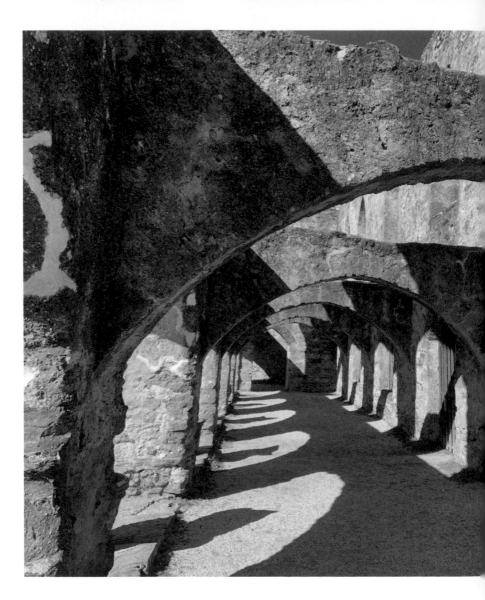

There is no obvious or definite rule about which orientation to use when taking photographs. My suggestion is to use the orientation that best suits the subjects, scenes, and scenarios you are capturing and how you are showcasing your work, whether it is in print or on social media, Instagram, a blog, or some other service or media. You will find that sometimes the orientation you feel will be best for the subject may be opposite to the best orientation for how you wish to share your image, in which case you'll need to weigh up what's most important to you.

◀ *While vertical photographs look absolutely fantastic on phones, horizontals are still the best option when it comes to displaying photographs and videos on desktop devices, laptops, and TV screens.*

Your assignment is to pick any subject (people, places, or objects) that you are especially fond of and shoot it in both a horizontal image orientation (Landscape mode) and vertical image orientation (Portrait mode). Compare the two pictures, side by side. Which image orientation (horizontal or vertical) flatters your subject best, and why? And does the image orientation you selected for your final shot complement how you will be using the shot—whether for print, Instagram, blog inclusion, or in another form?

ASSIGNMENT
04

TIPS

- One of the keys to getting comprehensive coverage of a subject or location is to stay mindful and present in the creative process.

- Don't harshly judge the creative thoughts and ideas that come in and out of your mind while you keep moving, exploring, and experimenting.

- A huge part of my own workflow process is to constantly be shuttling between different optical lenses. Using a variety of focal lengths helps you tell different stories via your lens selections.

- I like playing a game in my mind that I'm on a bona fide magazine assignment, with my role being to deliver to an editor a body of work that is interesting, varied, diverse, and different. Click!

▼ *As a creative exercise, I visit this temple near my house and walk around it, shooting from different perspectives and with different focal lengths. It seems like I always return with dozens of new variations on a familiar theme.*

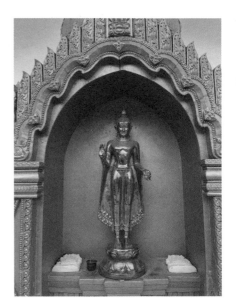

SHOOTING GALLERY

In my view, the difference between consumer snappers and prosumer hobbyists is that the latter seem to shoot more photographs of a single subject or scene than they will ever need. Consumer types seem to shoot more by the "one-and-done" mantra. This type of approach is limiting and often nets disappointing results.

Whether taking carefully planned shots or shooting casually, I tend to take anything in the neighborhood of five to fifteen different shots of a subject or scene from various angles, perspectives, and exposures. I reason that, if a photograph is worth my attention, then it is also worth the creative time, energy, and vision to do it right and well. Then—sometimes hours or even days later—I pick the best shots from the sequence and invest in them more curation and post-processing time. My general shoot-to-edit ratio is high—often in the ten-to-one range. It may come as a surprise to you that, more often than not, to get a prized "keeper," you might first have to steward through a dozen variations of the same image. In my experience, it's easy to create good images. It's a lot harder to curate better ones.

For this assignment, I want you to pick one of your favorite locations nearby. Spend an hour shooting this location from multiple angles and perspectives. Resist the urge to stop shooting—keep your feet moving. Explore the subject from every vantage point that inspires and motivates you. Think of it in terms of telling a narrative or a story, not with a single image, but via a collection of images, each reflecting and reinforcing a single, visual theme. Shoot, shoot, then shoot again.

ASSIGNMENT

05

TIPS

- When I am out shooting, I mainly focus on either photo capture or video capture. It's difficult, sometimes impossible, to mix the two.

- When you are on location and shooting all the modes, make sure you have ample power and plenty of storage capacity before heading out.

▲ **Photo**: The default mode used for taking standard photographs and Live Photos®.

▲ **Portrait**: For photos with a depth of field effect.

CHOOSE YOUR MODE

I have had some form of camera in my hands since 1975. I am, at my core, a proud, passionate, prolific, and productive photographer. That will never change. Yet over the past decade, shooting around the world exclusively using iPhone cameras has taught me that different emotional moments require different technical modes. Indeed, I have not only come to appreciate the built-in shooting modes, I have also become an ardent, skilled, and wholehearted practitioner with every single one of these modes. I love them all.

▲ **Pano**: For panoramic scenes.

▲ **Square**: Use this to switch between square, 4:3, and 16:9 aspect ratios.

▲ **Video**: For recording standard videos.

▲ **Cinematic**: For recording videos with a depth of field effect.

Including the Photo mode, there are eight different shooting modes, each designed for different types of photographic and video capture. The modes I use most often are Photo, Portrait, and Pano, with the intention of sharing my work in books and magazines, on blogs, and in social media posts. However, increasingly I'm using the video modes more—Video, Time-lapse, Slo-mo—for my work that's appearing on YouTube and on online tutorials, meetings, and presentations.

▲ **Time-lapse**: For recording time-lapse videos.

▲ **Slo-mo**: For recording slow-motion videos.

For this assignment, each morning and afternoon over the next four days, choose a new mode and spend at least 30 minutes exclusively with it. Learn how each behaves and understand why you might use each one. Which ones do you like, and which don't you especially care for? Create one deliverable capture from each mode that you are proud of and that demonstrates a relative efficiency and proficiency with understanding the tech behind the mode.

ASSIGNMENT

06

TELLING STORIES

This I can tell you with absolute certainty: in the internet economy, stories trump single images. Stories work because, at most levels, they engage our emotional core, and leave the final interpretation of the story up to individual taste, preferences, bias, and style. Different camera shots tease and inspire us. There is simply no better vehicle to get others to feel a connection to your photographic story than to craft your story, as a filmmaker might, through intentional camera shots.

"Camera shots" refer to the subject's size within the frame. The long shot, also known as the wide or establishing shot, sets the overall scene and provides a sweeping context for the story you are trying to tell. This long shot generally includes a full-length shot of your subject, plus a healthy dose of the surrounding area and details.

The medium shot shows less of the wider context of the scene, and instead introduces more detail and intimacy. If shooting a person, it would typically be a waist-up shot to add more personality.

A close-up shot is a photograph taken of a person or an animate or inanimate object at a close range, to capture the minute details of the subject and provide further familiarity and attachment.

Even though I consider myself a photographer, I still think like a filmmaker, and rarely exclude these compositional and cropping variations from most of the subjects and scenes that I shoot.

▲ *Although this is not a hard and fast rule, generally I first shoot wide, then I move in closer for my medium and close-up shots. The wide shot gives me that "big picture" impression. Then I use the different lenses to isolate the individual parts of the subject or scene that I feel reflect an important part of the overall story.*

Let's pretend for a minute that you are a filmmaker. I want you to tell a story in three photographs. Take a long shot, a medium shot, and a close-up shot. Do these photographs collectively give the viewer a fuller picture of the scene or subject you are covering? What we are aiming for here is for each photograph to give the viewer just a tiny bit more information about what you experienced in real life.

ASSIGNMENT

07

TIPS

- There is no need to get carried away with this simple guideline—sometimes the best composition for your object or subject is smack in the center of the frame.

- I tend to always keep the rule of thirds grid activated as a visual reminder for me to challenge the viewer's eye to wander around the photograph and take in the whole story.

▶ *Some subjects work just fine dead center in the frame. But most subjects are more interesting and dynamic when placed on one of the four rule of thirds intersection points.*

RULE OF THIRDS

One of the easiest ways to make your photographs less static and predictable, regardless of the subject matter, is to use the handy, built-in grid that comes on your iPhone camera, called by many "the rule of thirds grid." It is probably one of the easiest features to activate (Settings > Camera), and also one of the most powerful and memorable.

The rule of thirds is a common compositional technique that breaks a photograph into nine equal parts using two horizontal and two vertical lines. This grid yields four intersection points. Studies have shown that when viewing photographs, people's eyes tend to naturally migrate to one of these interaction points rather than the center of the frame. So, by intentionally and deliberately placing your primary or secondary subject on one of these intersection points, you will create an off-centered, asymmetric photograph which is more artistically pleasing to the eye than one with the subject in the center. Ideally, the empty space in your photographs, created by employing the rule of thirds grid, gives the composition breathing room and helps focus the viewer's directional gaze.

For this assignment, take one of your favorite subjects and shoot it in four different ways. For each version, place your subject on one of the four rule of thirds intersection points. Which ones feels best to you? Which photograph seems the most compositionally pleasing, and why?

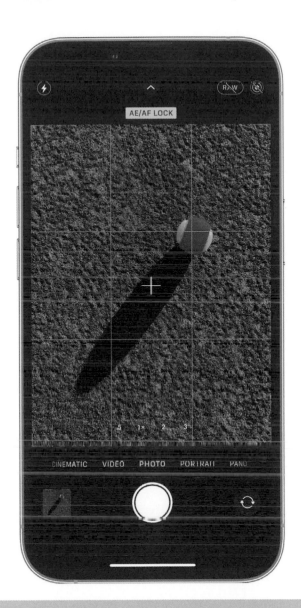

PRO TIP

While there is no real science to the rule of thirds, visual researchers tell us that the four sweet spots created by the grid are common resting spots for the viewer's eye as they navigate through a photo. The upper left intersection point gets the most immediate attention, followed by the lower left intersection point. The lower right intersection point is the least visited of the four.

ASSIGNMENT

08

TIPS

• It's likely that, as you develop ongoing routines and rhythms with all the lenses, one or two will become your go-to favorites, but don't neglect the others.

• Another interesting exercise is to use only a single lens in a particular location so that you can become intimately familiar with how it worked, and what the results were when shooting different subjects and scenes.

THE BIG PICTURE

Most people new to iPhone photography shoot the lion's share of their pictures on the Wide (main) camera. This isn't a bad thing at all because the main camera and lens combo is the highest quality in the iPhone ecosystem. However, I can't stress enough the importance and relevance of using all the cameras in your iPhone for different applications.

All iPhones will have a main lens and a front-facing selfie lens. Starting with the iPhone 7 Plus, some models also have a dual rear camera system, and current Pro and Pro Max models have a third rear camera. It is not just vital but crucial to understand the unique role each of these camera and lens combos plays in your ongoing iPhone photography efforts.

This might be a bit of old-school thinking, but I tend to look at my iPhone device as a camera with four prime lenses: wide, normal, telephoto, and macro, and with these I can shoot almost anything, anytime, anywhere. While these tiny iPhone lenses don't remotely compare to or compete with dedicated camera lenses, the iPhone lenses coupled with brilliant computational competence means there really isn't much that these multi-lens devices can't handle remarkably well.

Want to get really good at this photography thing? I have a game-changing suggestion for you. Every day for a week, take a single shot with each camera and lens combination, then at the end of the week compare your results. See how when you change focal lengths, you change your story. As you begin to get comfortable using all the lenses for different scenes, subjects, and scenarios, your photography will rise to new dimensions.

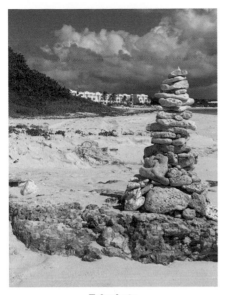

Telephoto

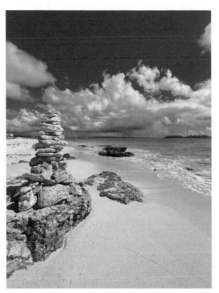

Ultra Wide

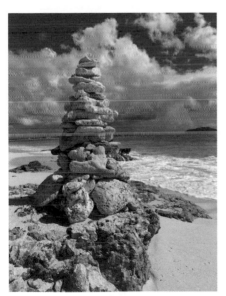

Wide

▲ *I tend to cover the subject or scene I'm shooting with all the cameras and lenses, then choose the best shot during the editing process.*

iPHONE NOTES

Here are a few guidelines when trying to choose the right lens.

- **Selfie camera**: selfies and video tutorials.

- **Ultra Wide**: landscape, urban, architectural, scenic, nature, and skateboarding photography.

- **Wide (main)**: everyday, common object, street, candid, and fashion photography.

- **Cropped Telephoto (2×)**: flat-lay, portrait, head-and-shoulders, and car photography.

- **Telephoto (3×)**: portraits, wildlife, concert, and sports photography.

ASSIGNMENT

09

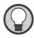

TIPS

- Changing your camera angle is all about altering perspectives. When you change perspectives, you are changing the viewer's psychological response to your photographs, which helps them connect more emotionally to your effort and work.

- I tend to shoot a bird's-eye view when I want the focus to be on the subject's shape and form, and a worm's-eye view when I want to create mystery and intrigue.

- Normally, I use a combination of both high-angle and low-angle views. For high-angle views, think two or ten o'clock on a watch face. For low-angle views, think of four or eight o'clock.

ANGLE FOR SOMETHING BETTER

When photographers talk about camera angle, they are specifically referring to the position of the camera relative to the subject. Any scene or subject can be photographed from multiple camera angles, and choosing the right angle makes all the difference in the world to a viewer's emotional response to the resulting image. In short, camera angles are always about the photographer's personal viewpoint.

Here's your assignment. I want you to shoot a subject—any subject—from five different vertical angles. Then, when you're editing the images later, determine which emotional response you like the best and think is the most flattering to the subject you're photographing.

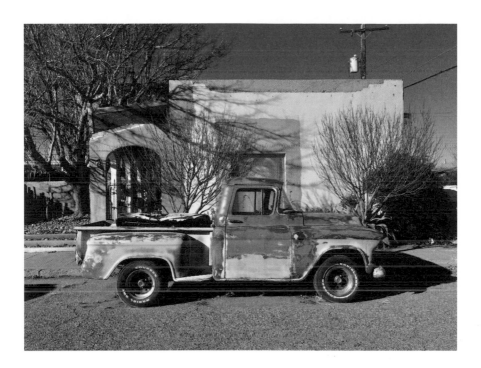

▲ **An eye-level angle** *Is the most common and neutral of the camera angles. It's often referred to as the "real world angle."*

PRO TIP

There are two other, lesser-known camera angles related to this topic. Both are equally powerful angles to generate different emotional reactions to your photos.

- A point of view angle (POV) attempts to show the viewer the image through the eyes of the subject, creating the visual illusion that we are seeing and experiencing the scene from the subject's perspective.

- A Dutch angle, also referred to as a canted angle or tilted angle, is an angle in which the camera itself is tilted to the left or the right. Dutch angles often enhance tension and disorientation.

◄ *A high angle* shows the subject from above. This angle can have the effect of making the subject look vulnerable or insignificant.

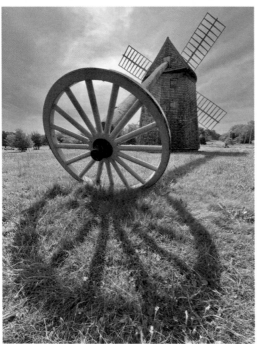

◄ *A low angle* shows the subject from below. This angle has the effect of making the subject powerful, dominant, grand, threatening, or even intimidating.

▶ **A bird's-eye view** is a shot of the subject directly from above. It is often the most striking camera angle, but it can be difficult to achieve in many situations.

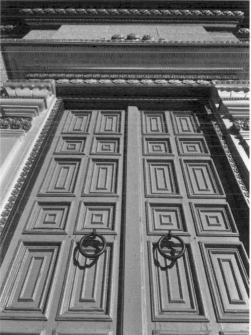

▶ **A worm's-eye view** is a view of an object from the ground, as though the observer were a worm. This is the opposite of a bird's-eye view.

ASSIGNMENT

10

TIPS

- The head and shoulders crop is one of the best for self-portraits.

- Use a vertical orientation.

- The simpler the background, the better.

- Try to shoot outdoors in the shade—direct sunlight is too harsh.

- Look right at the camera, not the screen, if you are using the Selfie camera.

- Try some with a smile, showing teeth, and others lips only—smile on the inside.

SELF-PORTRAITS

I tend to think of many selfies as disposable snapshots, taken without much artistic or journalistic intent. However, I'm a fan of a well-taken selfie, especially if you think of cell phone photography more like a lingua franca for communication in general. Selfies are fantastic deliverables for self-expression and self-validation.

I think of self-portraits (as opposed to selfies) as planned and studied photographs. They are more intentional, deliberate, and purposeful attempts at taking a flattering shot of yourself than a selfie, and learning to take them is an inspiring and valuable part of photo education.

For this assignment, I want you to be both the subject and the photographer. I do not want you to take rapid-fire, casual selfies at arm's length, like most others do (at least not for this assignment). Instead, I want you to be exacting and thoughtful about your approach to self-portraiture. With self-portraiture, you are the subject. How do you see yourself? What message do you wish to convey? How do you want others to see, understand, and appreciate your likeness?

Take a minimum of ten different self-portraits. Set up your iPhone on a small tripod and use the self-timer feature, set to ten seconds, to allow you time to get back into the shot. Then show the photos to a family member or friend and get some feedback. Is their reaction to the photos the same as what you intended, or different? Is the likeness they see the likeness you desire to convey?

PRO TIPS

- You can shoot a self-portrait with either the rear (main) camera or front (selfie) camera. I personally like the front camera for this, as you can see yourself in the display.

- On the newer flagship iPhone cameras, the front camera has built-in autofocus, making both quick selfies and planned self-portraits very easy.

- It's best to use the built-in timer (either three or ten seconds) and watch the countdown. Your iPhone camera's flash will blink as the timer counts down.

- Turning off Live Photo automatically activates Burst mode when using the timer, so you get a selection of ten photos per shutter click.

▲ *I'm probably showing my age here, but I would love to see people shoot fewer casual selfies and more intentional self-portraits. For self-portraits, done well, highlight what good photography is all about.*

ASSIGNMENT

11

- If doors have interesting elements on either side of them, shoot in horizontal mode. If not, crop in tightly and shoot in a full-frame vertical orientation.

- Don't overload your viewer with the inclusion of too many color elements, which create "color fatigue" (see Assignment 45). Stick to one or two color themes per photo.

- Doors generally look awesome in both direct (hard) and indirect (soft) light.

- Pay close attention to all the detail surrounding the door: mailboxes, door knobs, rails, stairs, vegetation, and so on.

WON'T YOU COME IN?

For the past seven years, I have photographed the Mardi Gras in New Orleans. A big part of its allure, which brings me back year after year, is not so much the street and festival life, but the French Quarter doors. For me, as a photographer, doors don't just tease our sense of visual intrigue, they invite symbolic participation in the process of capturing them.

Doors are one of the most visually rich and nuanced subjects a photographer could ever shoot. A door or doorway symbolizes a transition and passageway to another space and place. Doors have both literal and figurative meanings, to both photographer and viewer. Doors are multidirectional and multidimensional—they let life in, and they let life out. Most importantly, doors are teeming with picture possibilities of light, color, and design.

Your assignment here is to photograph doors. Grab your iPhone and spend an hour in your neighborhood looking for picturesque and charming doors. Take a variety of shots. Shoot some of these doors contextually with a wider lens, showing a sense of context and environment. Shoot other doors up close and personal, maybe with a zoom or telephoto lens, showing a sense of content and intimacy. You could even take this assignment a step further and see if you can tell a story, showcasing all the doors you photographed on your photo walk.

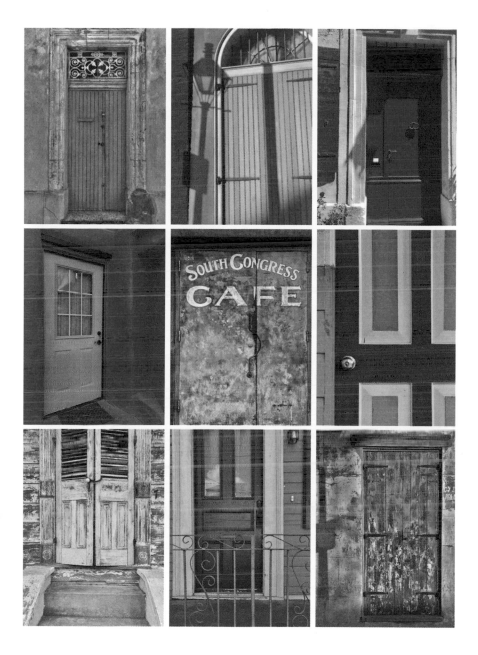

▲ *It's almost impossible not to be attracted to the color and geometry of doors. To isolate the door from distracting and unwanted surroundings, I tend to use the Telephoto lens and crop tightly.*

ASSIGNMENT 12

TIPS

• If you are creating this type of image from scratch, dress your subject in an eye-popping colored outfit, so that they stand out against nature's neutral colors.

• Place your person on one of the four intersections of the rule of thirds grid.

• For added interest, have your subject hold an interesting prop, such as an umbrella, helium balloons, or an old vintage camera.

▶ *The best way to show proportion and relative size in any photograph is to include a small human figure in the grand landscape. When we look at photographs without people, it's challenging for us to visually determine size, scope, and segmentation.*

IT'S THE LITTLE THINGS IN LIFE

Back in the day, when I was commissioned to take a lot of nature and lifestyle photographs, I was told by more than a few editors to make sure I photographed a healthy dose of images that included "little subjects in big landscapes." Why? Simple. To show a sense of scale and proportion. Adding a human figure, even a tiny one, to a sweeping or sprawling landscape or scene, is often all a viewer needs to make sense of the picture. Adding a tiny person to a big landscape not only adds warmth, personality, and humanity, even more importantly it also adds a sense of size, scope, magnitude, dimension, and depth.

I love beautiful, quiet, natural landscape shots. But, if you think about it, isn't it even more important and grander to celebrate how we, as human beings, connect and interact with our natural world? For this assignment I want you to get out of town and find the most picturesque landscape in your area. Shoot the landscape both with and without a person in it. Do you see the difference? See how the shot with a little subject in it adds character, disposition, temperament, magnetism, charge, mystery, and familiarity. In contrast, the same scene without a person is more of a study of nature, creation, the cosmos, and beauty.

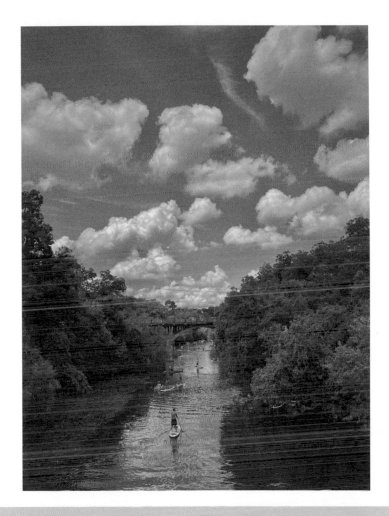

PRO TIPS

There are a number of things to consider when shooting a "little subject in a big landscape":

- Use the Wide (main) lens (1×) or the Ultra Wide lens (0.5×).

- To make the person really stand out, try placing them against the sky as a backdrop.

- Optimum light happens an hour after sunrise and an hour before sunset—the golden hours (see Assignment 16).

- For more dramatic visual statements, try silhouetting the person in the final photograph.

- Because the inclusion of a person in the frame grabs the viewer's attention, make sure the subject is relatively small in the composition.

TIPS

- Not all subjects will work equally well with infrared. However, you can stack the odds in your favor, whether you are shooting color or black and white, by including lots of green vegetation and a sky filled with cumulus clouds.

- I tend to use these infrared filters more for pastoral and landscape scenes, often without human elements in them.

- The images straight out of the Firstlight app tend to look a little overexposed. So, I darken and increase saturation ever so slightly using the Photos app before publishing them. Voilà!

INFRARED

I know, it's crazy, but there are lots of wavelengths of light, all around us, every day, everywhere we go, that are not at all discernible to the naked eye. Wavelengths in the visual spectrum for photography range from about 400 to 700 nanometers (nm). Infrared light is in the 700 to 1,200nm range. Infrared photography, in its purest form, is used to capture some of these unique and seemingly invisible wavelengths.

If you want to shoot infrared-style photos with your iPhone, you have a couple of options. The easiest and least expensive option is to buy an infrared simulation or conversion app, such as Filmic Firstlight or RNI Aero. For the Firstlight app, you have to shoot with the app while creating the images. For the Aero app, you can pull any image from your camera roll and convert it to Infrared. Both apps are incredibly realistic infrared simulations, and I use both regularly for my infrared work.

The more expensive option is to purchase an infrared screw-in filter and mount it to your iPhone for shooting. For this option, be prepared for lots of rinse-and-repeat experimentation to achieve the desired result.

For this assignment, I want you to download an infrared simulation app. They have different false-color options to play around with. Spend an hour outdoors in full, bright sunlight and create four different infrared samples. Then post them online— anywhere—and see what sort of response your wild and crazy efforts receive.

▲ Sometimes I like to shoot using an infrared app so I can see the results in real time; at other times, I like to take the shot normally and edit it in infrared instead. In either case, the most striking infrared results often come when the subject or scene composition is plain and simple.

TIPS

- Whether you are shooting new portraits with an app or simply converting photos from your camera roll, the key to consistently creating outstanding and noteworthy portraits is to simplify your backgrounds—make the focus the person and not the setting.

- Another tip when creating pleasing portraits, reminiscent of early portrait photography, is to turn your model's body 45° off-camera and then bring only their face around to a full-frontal position.

iPHONE NOTE

When I am shooting portraits, rather than rely on the Camera app to focus, I tap to focus on one of the eyes and then lock that focus point by long pressing the same spot until the AE/AF lock shows.

▼ *Early tintypes were made by creating a direct positive on a sheet of coated metal. Their electronic descendants can offer that same heirloom quality.*

TINTYPES

Tintype portraits, like the earliest daguerreotypes, were most often made in formal photographic studios of the day. As photography became more popular and in demand, it moved from formal studios to informal sidewalk settings and situations—open-air fairs, carnivals, and street corners.

Tintype photographs were made by creating a direct positive on a sheet of metal. Compared to other photographic processes available at the time, they were relatively inexpensive, easy, and quick to make.

There is an iOS app called TinType that provides several effects for creating your very own homages to daguerreotypes and tintypes with the minimum of fuss, or with a bit more effort the VSCO, Huji Cam, Nomo Cam, and Argentum retro-filter apps can be used as a starting point.

I am a photographic purist at heart. I like my photographs to look like photographs, not illustrations. But there is just something so special about tintypes that makes me feel connected to our shared history in photography. We proudly stand on the shoulders of giants. The purpose of this assignment is to get you to feel the same sense of wonder and awe. I want you to pretend that you are an itinerant sidewalk photographer of the 1860s and 1870s. Create your own vintage family album by taking a tintype portrait of everyone in your family. Or if you prefer, you can pull photos from your camera roll and convert them into tintypes.

ASSIGNMENT 15

TIPS

- Based on my own experience, I would choose final images that are square or close to square in orientation.

- Anything goes when it comes to creating retro-style images—scratches, grunge, light leaks, texture, frames, borders . . . you name it.

- The fun part of creating this type of imagery is that you don't need tack-sharp images as you might for other traditional apps. Sometimes a slightly soft or out-of-focus image carries just as much emotional resonance as a razor-sharp one.

RIPE OLD AGE

In 1948, when Edward Land invented a camera that no longer required the photographer to take their film to a darkroom for development or printing, instant printing was born. And we have never been the same since—instant photography ushered in a new zeitgeist of sharing moments and memories.

After the first, uber-popular, black and white prints came Polaroid's peel-apart color prints in 1963, followed by non-peel-apart color prints in 1972. Visual historians tell us that by 1977—the height of instant photography's popularity—Polaroid, despite fierce competition from Kodak, owned approximately two-thirds of the instant camera market.

Fast-forward to today, there are dozens of apps that will help you make photographs that look like Polaroids, ready to share and shine on social media. Some apps will allow you to shoot with the filter, others will allow you to convert camera roll images to have various retro looks and feels. I want you to go through your camera roll, choose some that you think will work, and download them, or take a few vintage-looking shots using the filter. Share the results online (on a Thursday, of course), using the hashtag #throwbackthursday.

▲ *In my house, a Polaroid camera was never more than an arm's length away, ready for when we wanted to record some casual life moment. These days, I just can't help enjoying this repeated sense of nostalgia every time I create a Polaroid-like effect through an app. It's a blast from the past—back to the future!*

ASSIGNMENT

16

GOLDEN HOUR

Photography, as you are well aware, is all about light. The proper utilization of light can turn the most mundane of subjects into a great work of art. Most photographers would agree that it's during "golden hour"—the rising and setting of the sun—when the light is the most flattering, picturesque, and easy to work with. At these times of day, the sun is low to the horizon and casts a long shadow, while the color temperature of the light is warm and golden. The light at golden hour (also called magic hour) is also one of the most mood-evocative times to bust out your camera and start shooting!

The actual science behind why the light is so golden during these windows of time is because of a phenomenon called scattering—tiny particles and water droplets in the atmosphere force rays of sunlight to change direction, and, as a result, shorter wavelength colors, like blue and violet, are filtered out, mostly leaving the longer and more visible wavelength colors, like yellow, orange, and red.

To do this assignment, you're going to need to shoot the same scene twice: once during the morning's golden hour (20 to 30 minutes after the sun rises), and then during the late afternoon's golden hour (20 to 30 minutes before the sun sets). At both these times, the sun will be roughly five percent above the horizon. Now compare notes. Which golden hour do you like most? Which one feels more inspiring, more photogenic, more pleasing? Are you noticing variations in the color of the light?

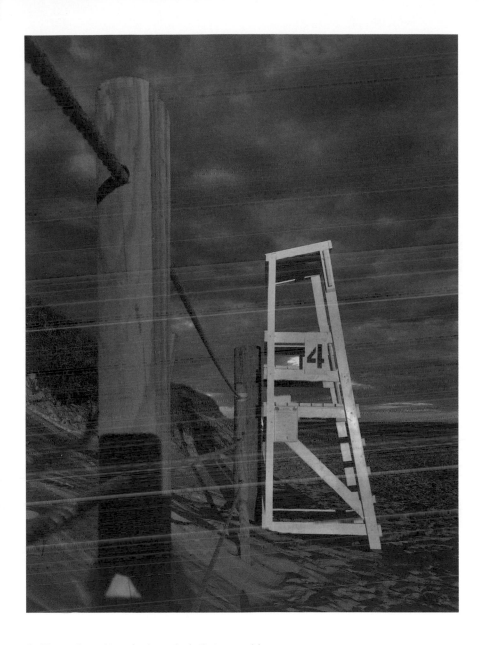

▲ *If I were forced to only give a single tip to a newbie photographer, it would be to increase the probability of creating a memorable photo by revisiting the subject or scene they are shooting during the golden hour, when the light seems to turn the ordinary into the extraordinary.*

ASSIGNMENT
17

TIPS

- The exact window of shoot time you have depends on where in the world you live, but it is normally around 30 minutes.

- For those that edit post-capture, shoot ProRAW® images. This format contains considerably more file information, giving you added flexibility for tweaking the color.

- If you use Google Snapseed, try the HDR Scape tool for more granular control over shadows, midtones, and highlights.

- If you are shooting during the morning blue hour, then face east when taking your photos. If you are shooting in the evening blue hour, face west.

BLUE HOUR

Blue hour happens twice a day. The first "blue hour" happens in the dawn light, before the sun comes up. The second happens during twilight, after the sun sets below the horizon. At blue hour, the light is stripped of the warm hues and tones and takes on a blue shade and cast. The light is in a constant state of change at this time, so you need to shoot quickly, but thankfully the iPhone camera is remarkably accurate at reading both color and exposure sensitivities at this time.

The light at blue hour seems to extend the practical dynamic range of the camera sensor, giving you more latitude for tricky exposures and compositions. Blue hour is the perfect time to blend the natural blue light with subjects that are artificially lit, such as monuments and street scenes. The cooler color is also pleasantly and romantically softer, helping to add emotion to your photographs.

I want you to go to your nearest urban center, bringing a tripod if you have one. Find an urban scene that suits you—one that includes a tall building, statue, or monument that is artificially lit. The key to this assignment is to capture a photo with a combination of both natural and artificial light: in other words, light from the blue hour sky as well as artificial light such as tungsten, mercury vapor, fluorescents, daylight bulbs, or neon from building windows, as well as street lamps, street signs, and other sources.

▲ *It's a pity that so many photographers pack up their gear and head home as soon as the sun dips below the horizon. They are missing some of the most spectacular light of the day: blue hour. Some photographers even call blue hour the second sunset.*

ASSIGNMENT

18

▶ *The process of adding filters to your photo during capture or editing is nondestructive, so you can always return to the original shot and try another filter.*

FILM SIMULATION

You don't have to be an art critic or curator to notice that analog photography and film simulation are increasingly popular. I think you can clearly see this deep and deliberate yearning for a return to a photography product and process that is less perfect and more real and authentic. Whether it's true or not, many see digital photography as too plastic, too contrived, too manufactured, and too computerized.

From our camera sensors and for the photos born from them, we want more believability, genuineness, originality, and fidelity. However, we don't need to run out and buy analog cameras and classic film stocks to achieve this. If you want your iPhone photos to take on the appearance of old-school analog film, then maybe it's time to try one of the nine iPhone filters that come with your camera app. They are accessed on the Camera app by bringing up the set of icons from the drop-down arrow, then selecting the icon with the three intersecting circles. You can run through all the filters and use the live display to show you the effect that each gives.

For this assignment, I want you to pick a single hero photo from your camera roll, then apply all the filters one by one. You will end up with nine or thirteen very different looking and feeling versions of your original photo. Which one do you like?

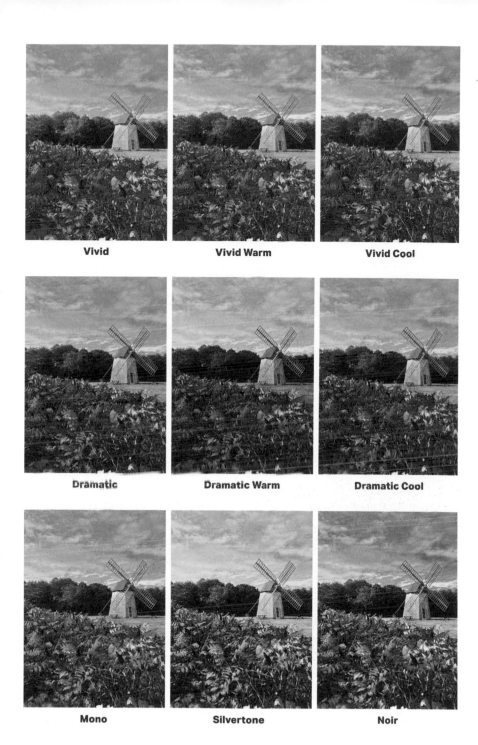

ASSIGNMENT
19
—

TIPS

- When I am shooting at a picturesque venue, I tend to make a first pass of the grounds, products, and vendors without shooting anything. Then I go back and focus only on the subjects and objects that hold the most photographic attraction for me.

- While our photographic taste and styles are wildly unique, I tend to look for neatly-aligned rows of fruit and vegetables of a single color for symmetrical compositions.

- The key to creating striking, isolated work is to find product displays that are on clean, unobtrusive backgrounds or table tops.

▼ *I'm a foodie at heart, and I love photographing food markets and stalls. For the ingredient shots, I try to get as close as possible and crop out any bothersome or less-attractive elements in the frame.*

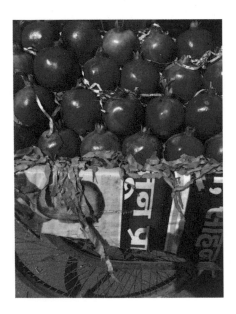

FRUITFUL PURSUITS

A local, outdoor farmer's market is the perfect place to spread your photographic wings. There is so much to see and take in—colors galore, rows of neatly-stacked fruit and vegetables, and often interesting vendors too. The challenge, for any photographer, is isolating what works and cropping out what doesn't—in other words simplify, simplify, simplify!

Quite often, what you exclude from a photograph is more important than what you include in the frame. It's a natural balance between the law of attraction and the law of subtraction. Not surprisingly, the most powerful and readable photos are often the simplest ones. So, take great care in simplifying your compositions, your lighting, and your chosen color palette.

This assignment will test your power for simplicity and clarity. I want you to shoot three separate images: fruit, vegetables, and a portrait or candid shot of a vendor. In each case, I want you to work hard at removing any and all distracting background elements, so the focus of the photograph is squarely on the subject itself, not the background. Make sure that the photograph includes only a single subject. Make it obvious to the viewer what you are showcasing and keep all contextual and surrounding accents to a bare minimum.

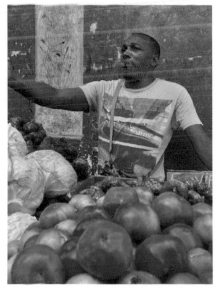

ASSIGNMENT

20

TIPS

- Like most of my food and small-product photography, I try to find a flattering and simple background that props up the color of the coffee mug I'm using.

- If the shot is only about the coffee itself, then I fill the frame as large as possible.

- If there is food involved, I might widen the scope of the photograph to reveal a more contextual sense, including both the coffee and edibles.

- If you are lucky enough to be sharing your morning coffee with a partner, friend, or coworker, don't hesitate to include a hand on the cup or even a warm smile too.

PRO TIPS

The first thing to consider when shooting a still-life is the angle of your camera in relation to the subject. Are you going to photograph at table level, so you see some of the content of where you are at? Or are you going to shoot a top-down, bird's-eye view of the cup and isolate it from potentially distracting surroundings?

The next photographic hurdle to jump is light. I tend to sit near a window, so I have the luxury of being able to use both natural and artificial light.

iPHONE NOTES

The iPhone camera is mostly optimized for shooting in bright, outdoor situations. But with every iteration of new flagship phones, the low-light capabilities get better and better. So don't hesitate to use your iPhone camera indoors. If you are shooting in dim light, use your body as a tripod or rest your elbow on the table to minimize any potential blur and camera shake.

▶ *The best angle for shooting a cup of coffee is a frontal, three-quarter view. This view will give you the best for showing off everything: coffee, cup, plate, and table.*

CAFFEINE HIT

I don't know about you, but I love my morning coffee. I also love how most baristas take such artistic care to make sure that the cup of Joe they are serving you is attractive and tantalizing.

To me, being the daily ritual that it is, morning coffee is symbolic and represents not only a new day, but also new hope, new opportunities, new dreams, and new plans and schedules. This is probably why I take as much care in photographing my morning coffee as the baristas do when making it.

For many, photographing their morning coffee is completely disposable photography—here today, gone tomorrow. But wait, maybe there is something more precious and memorable here. Maybe there is a moment here for all of us to experience, which will live far longer than our six-ounce chug.

The assignment here is to take one of life's simple pleasures—a lowly and humble cup of coffee—and photograph it in such a way that it represents your emotional state of mind at the time. Make it beautiful. Make it lyrical. Make it personal.

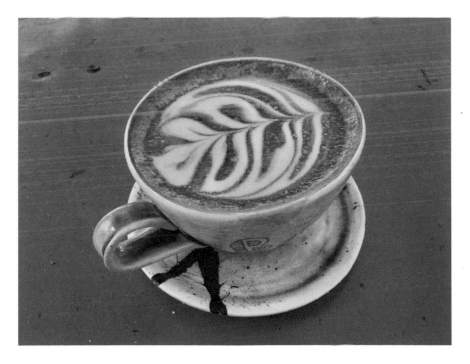

ASSIGNMENT

21

TIPS

• As you begin to learn to recognize and appreciate the part of your composition in shadows, you will develop an equal appreciation for the highlight areas, too.

• The best place to learn how to take advantage of shadows is to shoot in black and white, then migrate to color when you have more experience.

• Make sure you are "exposing for the highlights" and let your shadows go dark. For iPhones, this means nothing more than tapping or long-pressing (if you wish to lock the exposure and focus point) on the highlight areas.

EMBRACING THE DARK SIDE

I'm not quite sure why photographers seem to spend so much time either trying to minimize or eliminate shadows in their photographs. It's as though someone told them at some point in their photography journey that shadows are bad and should be avoided. Shadows, when used properly in photographs, are not only not bad, they are good—great even. Shadows create contrast and drama. Shadows reveal form and texture. Shadows direct and focus the viewer's attention.

As creative photographers, we need to stop thinking about shadows as simply the "dark" part of the frame. Shadows are as equally important to a photograph as light. In fact, shadows, whether you realize it or not, are the very thing that draws a viewer's attention to light. Learning to master shadows is as critical as learning to master light. When you are just starting, it is easier to recognize and appreciate shaded elements when you shoot in black and white rather than in color.

The mission of this assignment is not to minimize or eliminate shadows in your photographs, but to feature and highlight them. Pick any three subjects (a person, place, or object) and make sure that at least half of the final image area in each photo predominately has strong shadows. Shoot each subject using a different black and white filter (see Assignment 18) and see which one you like best.

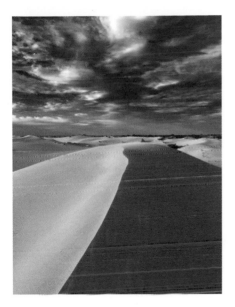

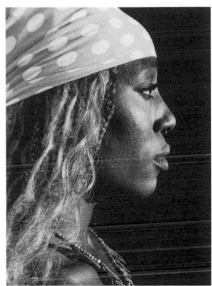

iPHONE NOTES

The more dark areas there are in a scene, the more challenging it is for the iPhone camera to create an optimum exposure. The iPhone camera's exposure metering system in Auto mode tends to "see" the dark elements in a photo, interpreting them as gray and not black, thus overexposing the final image. So when you are shooting a scene with high contrast, you will want to take your exposure meter off Auto and lock your exposure on the bright, not dark, parts of the frame. This, in exposure-metering parlance, is "shooting for highlights." Let the dark areas go naturally black. We are not trying to minimize or eliminate shadows, but let the black parts of the frame play their critical part in adding drama, texture, shape, form, and mystery.

▲ *Including a healthy portion of shadow gives almost any photograph depth. It helps the illusion of creating three-dimensionality in a photograph.*

ASSIGNMENT
22

TIPS

- Get as low an angle as possible and bring the foreground into the frame.

- For added drama, the best time to shoot these types of shots is at early morning or late afternoon.

- Please be careful and exercise extreme care and caution while stopping on any road.

▶ *I love using the Ultra Wide lens for the hyper low-angle, wide-angle shots, and the Telephoto lens when I want to show the road, compressed and in its landscape context.*

HIT THE ROAD

Feeling pent up? Anxious? Troubled? Get in your car, get lost, feel the wind on your face, crank up the tunes, feed your soul, disconnect from the humdrum, be the artist you were born to be, and listen to that small voice within you. It's time for a road trip with your camera. Even if you live in an area where you don't enjoy rural, pastoral, open roads, it's still possible to metaphorically "hit the road" and disconnect. Hitting the road, with a camera in hand, is often more of a state of mind than a physical place and space. The open road, like many symbols and icons that we photograph every day, invites exploration, participation, and direction.

It doesn't matter too much where you end up. Your destination could be a town you've never visited, but don't for a single minute think that small-town photography can't mean big-time results. It can and often does. It doesn't even need to be the destination or your trip that becomes your photographic subject—one of the many obsessions I have on road-tripping is photographing, literally, the open road. There is just something magical and mysterious about the physical road that lives and breathes beneath our tires and feet.

This road trip assignment that I've set you will only work if you are out in the countryside—no buildings, no homes, no structures—just the open road. I want you to illustrate the theme, "Not all who wander are lost." What does that look like to you? More importantly, what does that feel like to you? And additionally, I want you, as a part of your final photograph, to incorporate some element of "road" in it. Let's go!

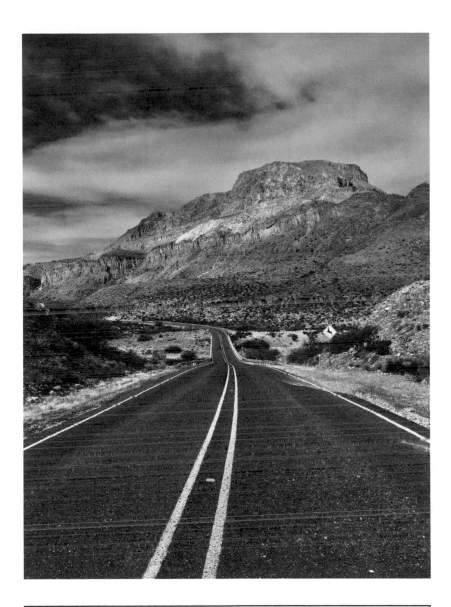

iPHONE NOTES

Ultra wide-angle lenses are popular with landscape photographers, as they expand the depth of the image and push the background farther away. When shooting these open road shots, I often use my 0.5× lens. On the iPhone14 Pro Max, this is an f/2.2 lens, with a 13mm equivalent focal length and a 120° field of view.

ASSIGNMENT

23

DOG DAYS OF SUMMER

Let's face it, people are crazy about their pets, and even crazier about photographing them and sharing their creations with family and friends on social media. In the US alone, seventy percent of households own a pet, which roughly equates to ninety million homes. This translates to a lot of photographs of pets!

Here's something that might surprise you: taking memorable photographs of your dear pet, either formal portraits or action shots, is not much different from taking portrait and action shots of humans. It is the same photographic skill, but obviously requires different skills for communication and direction.

When shooting pets, obviously they look their picture-perfect self when they are properly groomed, but there are other things to consider as well. Does your pet have a signature look that you want to capture? Make sure not to forget those accessories to add an element of flair and style—leashes and collars, bows, bandannas, and favorite toys to name but a few. Two additional things that always help with photographing pets are firstly, give them a good walk or playtime before your session, and secondly, bribe and reward them with their favorite treats.

Your assignment here is not simply to take a documentary record shot of your (or a friend's) pet, but stylized photographs that really show off the animal's personality through candid and formal portraiture. You have a thirty-minute window to capture and deliver six different photos that perfectly encapsulate the character and charisma of your beloved pet. Ready, set, go. Woof woof!

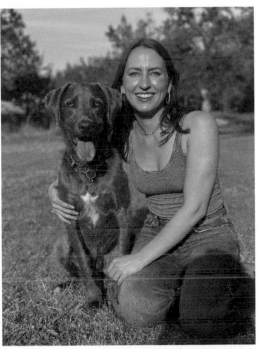

◄ When I photograph someone else's pet, I always start with the pet and pet owner together. Then once the pet gets used to me, my camera, and my scent, I can take attractive pet portraits.

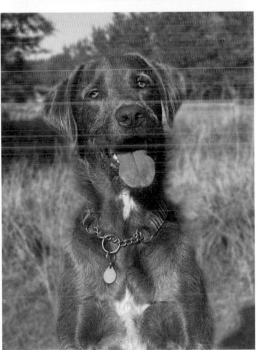

PRO TIP

Think about your pet's routine when you start planning when to take the photos. For example, if you're doing a formal portrait, then perhaps shoot right after the pet's nap time. Conversely, plan action shots for when your pet is full of energy.

iPHONE NOTES

For pet action shots, just as you would when photographing active children, shoot in Burst mode. Use Portrait mode to blur your background and simplify your composition. Formal, full-frame, straight-on portraits of pets will look better and more natural with the Telephoto rather than Wide (main) or Ultra Wide lenses.

ASSIGNMENT

24

TIPS

- Natural light is the best for flat-lays as it tends to organically wrap around your subject in a flattering way.

- You can go to almost any camera or craft store and buy inexpensive backdrops in various colors, textures, and themes.

- You can get extension arms that screw into the top of a tripod, allowing you to shoot from directly overhead without the legs getting in the way.

- Take care not to fall when shooting from a ladder or other raised platform.

A BIRD'S EYE VIEW

Flat-lay photography is an artfully arranged still-life shot captured directly from above. It is particularly popular for food, fashion, small product, craft, and hobby photography. It's the careful composition of the individual elements and their arrangement as a whole that makes flat-lay photos so arresting and captivating. Flat-lay photography is still-life photography on steroids.

In my own flat-lay photography, I tend to use objects with contextual significance and relevance, styled minimally for impact. Most flat-lays have one to three featured stars, and the remaining smaller items in the frame act as supporting actors. When selecting your objects and backdrops, try to limit your color scheme to one or two main hues. Keep your composition as simple as possible—eliminate everything that doesn't accent your visual story, and give each of the still-life elements ample breathing space. Avoid the urge to fill up every single bit of space in the composition.

For your flat-lay assignment, try to tell a story with a single shot. Gather several common objects from around your home that represent a unified visual theme. Lay these objects out on a table or another type of plain background or backdrop, and photograph the setup by standing on a stepladder. Make sure your camera is parallel to the flat surface. With most flat-lay photography, you are both "selling" and "celebrating" objects in your composition. Keep things straightforward, uncluttered, and pleasing to look at.

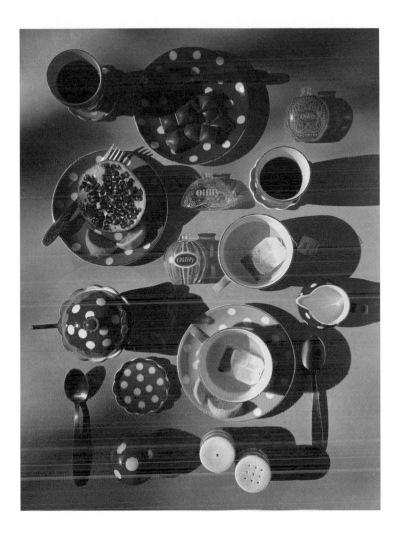

▲ *For this flat-lay, I used colorful dishes, strong afternoon light, and a minimally propped and styled composition. It's amazing how very graphic almost any subject looks from directly overhead.*

iPHONE NOTES

- If you are shooting in moderate to low light conditions and want to minimize camera shake and possible blur, use the self-timer or wireless remote.

- For the most flattering flat-lays, I like to get up high and use the Telephoto lens to compress and flatten perspective in the final image.

ASSIGNMENT

25

—

TIPS

• While a small glass mirror will be the best and most realistic reflection, in a pinch you can use any highly reflective surface, like a car rooftop or hood.

• Constantly be on the lookout for naturally-made reflections in water, where you can shoot in the same way and style.

▶ *The key to this style of photography, whether using a mirror, a puddle, or any other reflective surface, is to turn your phone camera upside down, so the camera lens is as close as possible to the reflective surface.*

MIRROR, MIRROR, ON THE WALL

Reflection photography is when you capture an image that is reflected off a surface. That surface could be glass, metal, a mirror, a window, puddles, a river, or the sea.

You don't need any fancy accessories to take what I call "mirror photographs." I went to the local hardware store and picked up a one-foot (30cm) square mirror. I packed it safely away in the trunk of my car, ready to be brought out when I see a subject that calls for it.

I assure you, done well, this simple type of photography will get you more oohs and aahs than you ever imagined. When I shoot iPhone photos taken with my mirror, the word that I hear most often is "Wow!" This mirror technique will not work with all subjects, but when it does, the results are remarkable.

For your assignment here, let's start out and try this technique with some sort of iconic building, monument, or statue. Look for a subject with a strong vertical orientation. Place the mirror on the ground or any flat surface in the foreground. Make sure you first clean and polish your mirrored surface, then place your phone upside down, so the top edge is against the mirror with the camera lens as close as possible to the mirror itself. You will be able to see on the iPhone's screen what the shot will look like. Adjust the placement of the mirror and iPhone until you're happy with the composition, then fire away. Click!

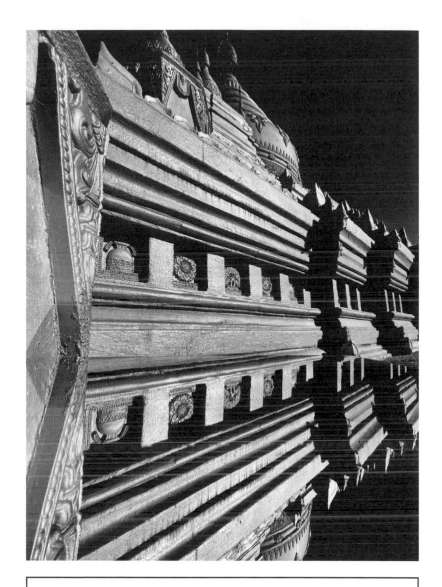

iPHONE NOTES

To prevent the iPhone camera from being fooled and focusing on the reflective surface instead of the reflected subject, lock your focus on the main subject before shooting. To lock a focus point (or exposure point), tap and hold for a few seconds, with your index finger, on the part of the screen where you want the lens to focus. When you see AE/AF Lock in a yellow box at the top of the screen, release your finger. Voilà. When AE/AF Lock is activated, the focus (and exposure too) is locked on that part of the scene.

ASSIGNMENT 26

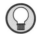

TIPS

- Find a location for your sign that either complements or competes with the sign's overall message.

- Make sure the light on your sign is the same light that falls on your background (so both can be equally seen).

- I make the sign the most prominent element of the composition and let everything else play a supporting role.

IT'S 5 O'CLOCK SOMEWHERE

When I saw the chair pictured opposite in a Cape Cod antique store on Route 28, I knew I had to buy it. On it was painted one of my favorite phrases: "It's 5 o'clock somewhere." To me, this expression has always meant: live by and on your own terms, even in photography. I photographed the chair in various settings that I was already familiar with. It would be my humble and passionate homage to photographic rebellion and revolution.

What I learned in the process of artfully photographing this chair in familiar settings was that the inclusion of words in a photograph transformed the original story of the scene for myself and for the viewer. While this chair series was initially only meant to be a cute, clever, and creative tribute to photographic independence and individualism, it became so much more over time. It sent me down a path of thinking about how words, letters, and numbers in a photograph change its meaning and message.

This assignment is about how the addition of text can significantly alter the narrative of an image. I want you to head to a local thrift, junk, or antique store and buy a sign or some other object with lettering that resonates with and speaks to you. Here's the fun part. Take that same sign and photograph it at three or four of your favorite local settings. Feature the sign somehow in the frame; it doesn't matter whether it's large or small. Think hard about what you are trying to say—are you trying to make your viewer laugh, think, question, or react in some other way?

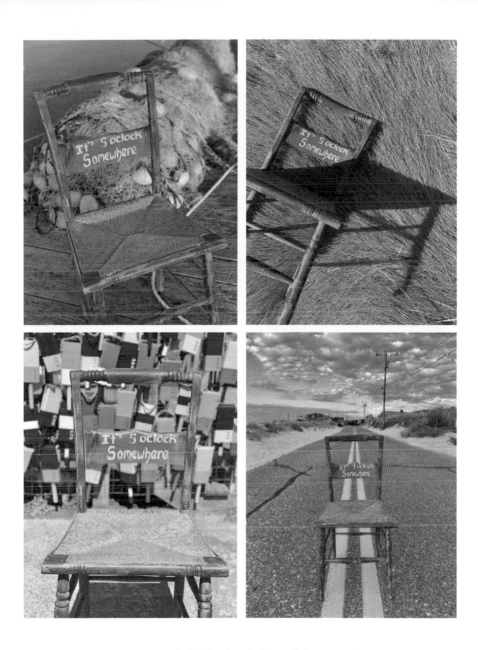

▲ Putting this chair in unlikely scenes where it completely alters the message of the photograph has given me hours of photographic pleasure. I shot a healthy dose of this series using both the 2× and 3× lenses to be able to tightly crop the composition and minimize background distractions.

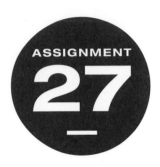

ASSIGNMENT

27

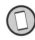

TIPS

• The more direct light you have on your subject, the easier it will be for your camera to autofocus (shoot outdoors, not indoors).

• Don't try this on a windy day as in macro photography the slightest subject movement will create an annoying blur.

• For most of my macro shots, I prefer a sturdy, full-size tripod, and point my iPhone camera slightly down on the subject.

• To minimize camera shake and blur when shooting either close-up or macro photography, I tend to use the built-in timer to trigger the camera shutter, allowing me to keep my trigger finger off the screen during exposure.

▶ *I've come to appreciate how the Wide camera and lens, coupled with advanced autofocusing systems, create stunningly sharp and beautiful macro photographs.*

SMALL IS BEAUTIFUL

Macro and close-up photography are terms that are often incorrectly used interchangeably. Close-up photography is generally done with standard phone camera lenses at close range. Macro photography is the process of taking small objects and subjects, including things like insects, flower petals, textures, and water droplets, and making them look larger than they are in real life. And for this type of extreme magnification, you need an iPhone lens with macro capability. Unless you have an iPhone 13 Pro Max or 14 Pro Max, which have true macro capabilities, the closest you are going to get to the subjects without a third-party macro lens is about five to six inches (12–15cm).

For this assignment, I want you to get comfortable with the minimum focusing distances of your iPhone camera lenses. Find something around the house or in the yard that you want to get a closer look at. Now, with each of the iPhone lenses that you have available on your device, see how close you can get to the subject you are photographing. Note how each focal length changes the perspective of the final image. Which one do you like the best? And why?

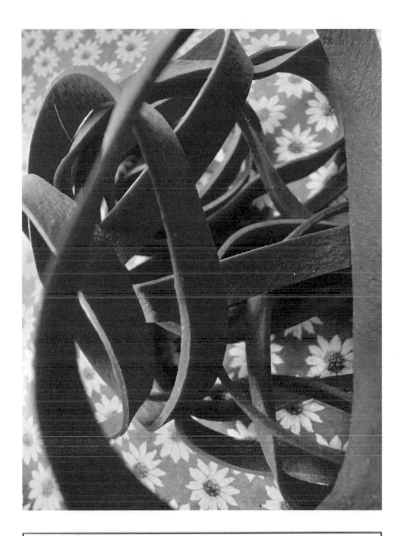

iPHONE NOTES

- Only the iPhone 13 Pro models and above have built-in macro capabilities with the Ultra Wide camera and advanced lens and autofocus system. They can create stunning close-ups with sharp focus as close to the subject as ¾in (2cm).

- All you have to do when using the built-in macro feature is keep moving closer and closer to your subject. The iPhone camera will automatically switch to the Ultra Wide (0.5×) lens for macro capture.

- Any iPhone camera that can take macro shots can also take macro slow-motion and time-lapse videos.

ASSIGNMENT
28

TIPS

- Don't give in to the pressure of feeling that you must photograph everything that could be interesting, it's far better to just shoot a few things well.

- When choosing your topic, follow your instincts, impulses, and intuition about what is photographically important to you.

- The inverse principle to this assignment is the law of distraction—stay clear of the subjects you don't enjoy or aren't interested in or invested in.

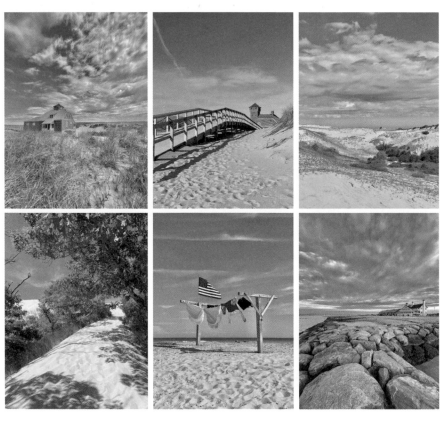

FIND YOUR BEACH

In the fast-paced, media-saturated world we live in, there is a seemingly endless variety of subjects to point our iPhone camera at: animals, life events, travel, nature, parenting, family, friends, architecture, selfies, food, music, sports, fashion, fitness . . . Unless we pay close attention to our affections and passions, it is easy to get lost in the myriad dizzying and unrelated subject specialties and micro trends.

It's not just important, but critical, that as creatives we "find our beach." This is the equivalent to what I call the law of attraction—that which makes us tick and click in photography. This mantra is so ridiculously simple: photograph the things you love most and avoid everything else. I think by doing so you will find a strong, unique, and powerful photographic proficiency and fluidity in your subject specialty. By shooting the things that make you tick, you'll intuitively know the essence of the subject and so you'll naturally take more remarkable and memorable photos.

For this assignment, grab a pen and a piece of paper. Write down, in list form, the top seven subjects, scenes, and scenarios you enjoy photographing more than anything else in this world. Now over the course of the next week, shoot a handful of shots each day of each theme or topic on your list. Then evaluate them at the end of the week. Is your "beach" a place? A subject? An object? Or maybe it's a concept, topic, or color palette? Perhaps it's a memory, person, dream, or hope? Perhaps it's something else? Something more? Something less?

PRO TIP

Let's be honest, taking photos day in, day out that you love and others admire is both a challenge and a chore. This is because exceptional photography isn't as simple as knowing one or two isolated camera features and functions. It is, instead, about the seamless, organic integration and combination of technique, technology, talent, tools, temperament, and tastes. However, you don't need to be a master of every iPhone camera setting, feature, and function. Find the things in the Apple® camera ecosystem that you are attracted to and enjoy most. Then learn those things well and have fun doing it.

◄ *In my world, "finding your beach" was a literal exploration of the Cape Cod beaches near me, but in your case, the journey could easily be symbolic or figurative. The key is to find out what makes you click, in every sense.*

ASSIGNMENT
29

TIPS

- Avoid using the iPhone's flash for food shots—it's ugly and harsh, and not at all food flattering.

- I always carry with me a mini tripod for food photography.

- Don't use the digital zoom to get closer. Instead, physically move the camera closer to the subject.

iPHONE NOTES

Of the three available iPhone cameras, the Wide (main) camera has the best sensor and lens and is always the best option for shooting food, whether indoors or outside.

▶ *I keep a good supply of vinyl and paper backgrounds and backdrops that I use for quick and easy food photography. I lean toward using my 2× or 3× Telephoto when shooting both high-angle and front-on shots.*

PRO TIPS

There's so much food photography out there, it's important to consider the range of different things you can do to make your photos stand out.

- Guide the viewer's eye toward a primary focal point and let everything else in the frame support the key food item.

- The two most popular angles for shooting food are directly overhead (bird's eye view) and a 45° frontal view.

- Most food looks slightly better and more attractive when it is brighter (overexposed).

- My food photography mantra has always been to make the food the hero of the shot, not the setting or context.

- There is a popular phrase among smartphone shooters, "the camera eats first." In other words, shoot your food photography before you start eating, while the items are fresh and looking perky.

- Simple garnishes go a long way in helping to add color and style to the plate.

- I personally think food looks best in natural, rather than artificial, light. If you are indoors, shoot near a window.

MOUTHWATERINGLY GOOD

Since I switched from a traditional camera to my iPhone, I've found I'm capturing artful moments of my food and dining experiences everywhere I go. This isn't because I want to try to make people jealous of what I'm eating, but because the meals we eat are another opportune moment to create photographic art.

It's true that most of the food photographs we see online look nothing more than unattractive and unappealing snapshots. Yuk. But forget what others are doing with their food photography and daily bread; let's focus on you. Let's create some highly attractive and tempting-looking pictures of our own creations and consumptions.

Your assignment over the next 72 hours is to photograph everything you eat. And I mean every morsel, from each course of a main meal to a snack you have to keep you going. Use different plates, different cutlery, different settings, different tabletops, different camera angles, different light, and different styling, so that at the end you will have, at the very least, several menu-worthy photographs to show off.

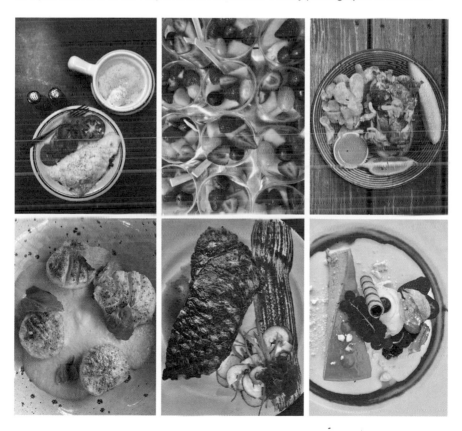

ASSIGNMENT

30

TIPS

- In my humble opinion, iPhones slightly overexpose red, so it looks a little washed out and a bit too neutral for my liking. To combat it, use your handy Brightness slider to slightly underexpose the red, especially if it's a dominant portion of the frame.

- Another way of improving the color in the Photos app is to use a combination of the Vibrancy and Brightness sliders to add back a little color punch to what your eyes remember seeing in the original scene.

PAINT THE TOWN RED

Red is the color of fire, blood, and passion. Some psychologists have said that seeing the color can boost brain activity, enhance metabolism, increase respiration rates, and raise blood pressure. Whether that's true or not, red is unquestionably an emotional and intense color, and it attracts the most attention. The positive emotions associated with red are desire, love, strength, power, and courage. Conversely, the negative emotions associated with red are danger, warning, anger, domination, control, aggression, and revenge.

Artistically, red is one of those colors that is almost impossible to ignore. It tends to overshadow and overpower other colors in a composition. Red demands respect, attention, and studied observation.

Red has always been a favorite color of mine. As a matter of fact, I think it would be fair to say that I'm more of a "warm" than "cool" photographer, in that I'm more attracted to warm colors (red, orange, yellow) than cool colors (green, blue, magenta). Interestingly, warm colors in a photographic composition appear to advance while cool colors appear to recede.

For this assignment, I want you to walk around your house, neighborhood, or a downtown area and photograph everything that you see that is predominantly red in color. Make sure that red is the subject matter, and minimize everything else. Create ten different, red-themed photographs that illustrate the title, "paint the town red."

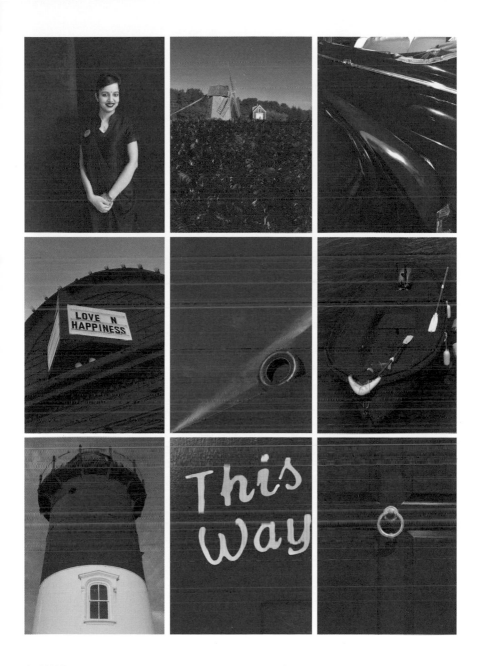

▲ CMOS sensors are a bit more sensitive to the red part of the color spectrum and the reds the sensors capture are often blown out or oversaturated. Shooting in ProRaw gives you far greater flexibility to tweak those reds in post-production so they match the color you saw with your eyes.

TIPS

- Quite often, the best time of the day to shoot cloud-filled skies is in the early morning or late afternoon, when the sun is closer to the horizon and rakes across the clouds' surfaces to add form and texture.

- The inclusion of clouds in a photograph helps create a contextual mood and emotional state about the subject or scene you are photographing.

- A polarizing filter can vastly improve the drama of your cloud photos by reducing the polarized light and darkening the clouds and skies.

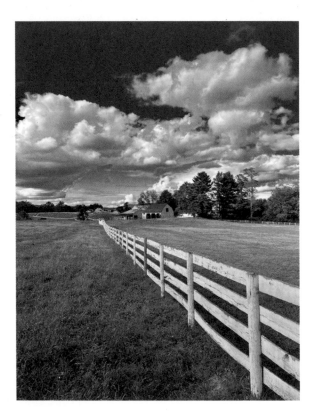

◄ *I'm constantly on the hunt for bright sunny days, when skies are full of white, fluffy cumulonimbus clouds. Having clouds in your photography as opposed to a cloudless sky is so much more dramatic and photographically interesting. When the sky is full of beautiful cloud formations, I sometimes open up my landscape shots to include more sky than land.*

HEAD IN THE CLOUDS

This phrase most often refers to someone who is absent-minded, impractical, or unrealistic; someone not really paying attention to the physical and emotional realities around them. Aren't most photographers like this? We have dual citizenship, with our feet planted on the ground, but our head and heart stuck in the clouds. We are dreamers, sentimentalists, castle-builders, wishful thinkers, visionaries. There is just something magical about witnessing a cloud-filled sky. It makes you feel like all is right with the world. There is hope and joy in life and nature.

As photographers, we love our cloudless, blue-sky days. But cloud-dotted skies can add a textual, spatial, and emotional element to photographs that far surpasses the one-dimensionality of solid-color skies. When I see a sky full of white, fluffy clouds, I tend to open up my landscape and make sure the clouds are a key part of the frame. They might not be the primary focal point, but they often can add secondary and tertiary emphasis, directing the viewer's attention back to the main subject.

The point of this exercise is not just to shoot full-frame pictures of interesting clouds. Anyone can do that. I want you to photograph a handful of pastoral landscapes where the sky and clouds occupy at least half to three-quarters of the frame. Landscape photography is vast and often unending. In both color and black and white photography, intentionally including clouds in the upper part of the frame can add a sense of mystery, interest, spectacle, or theater to any photograph.

IPHONE NOTES

- For these types of "open landscape" shots, where the landscape opens up to the sky and clouds, I tend to use the built-in Ultra Wide lens, which boasts a whopping 120° field of view. It's the perfect lens for grand, sweeping, far-reaching scenic photography with clouds.

- Another common workflow trick I use to make images have more dramatic clouds is to use the high-contrast black and white Noir filter.

- There is nothing more dramatic and inspiring than shooting a time-lapse video taken on a tripod of moving clouds sweeping the scene. When you use the Time-lapse mode, the final video will be a maximum of 40 seconds and your iPhone will drop more frames the longer the recording is to achieve this. In a short video the gap between each frame will be half a second, so at the 30 frames per second playback speed, each second will represent 15 seconds of recording time, while if you record for an hour, the gap between each frame is 3.5 seconds and a single second of the final video will replay 105 seconds of the original recording.

ASSIGNMENT
32

TIPS

• If the thought of simply wandering around shooting everything and anything that you notice terrifies you, then narrow the scope of your efforts and concentrate on a more narrowly defined subject, object, color, theme, or topic.

• Since the only person you are trying to please here is yourself, have fun with the process. Let yourself go, color outside the lines for a change, and be your creative self.

• The key to developing a rhythm with this type of photography is to keep shooting and stay focused on the capture experience. Resist the urge to edit or share the work immediately after taking a shot.

ABSTRACTION

When I refer to abstraction in photography, I'm not necessarily talking about the experimental, conceptual stuff (though there is certainly a place for all that too). For me, abstraction in photography has more to do with noticing, appreciating, and capturing the cracks, creases, and crevices of our day-to-day lives.

Abstraction lives and breathes all around us, every day and everywhere: graffiti, urban murals, peeling paint, textures, letters and numbers on the sides of buildings, color juxtapositions, shadow play, light nuances and subtleties, lines and shapes, still-lifes—all the things that no-one notices but you. This is our photographic life. And this is our beautiful mess.

Abstract photography of everyday scenes is where I think the iPhone camera really shines. It is always with you 24/7, 365. You are no longer a spectator in abstraction but a participant. You have the superpower in your pocket or palm to create everyday images that you never dreamed were possible.

I want you to record six different abstract still-lifes by the end of the day. They don't need to be content that you can explain. They only need to be subjects or scenes that are beautiful and lyrical to you. The six abstractions I want you to shoot are graffiti, letters or numbers, texture, color, shadow, and nature.

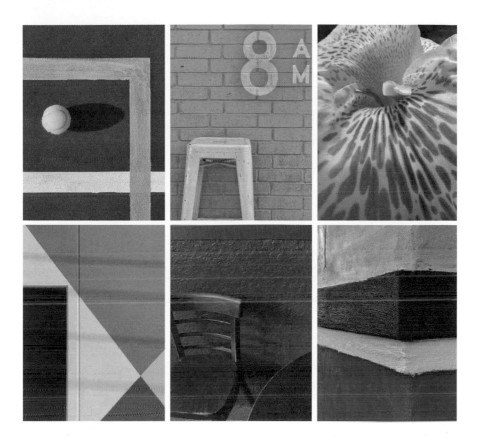

PRO TIPS

One of the key ingredients for developing an eye for everyday abstraction is to stay mindful and focus on the present, trying your best not to overthink what you are about to shoot. There is a time and a place for analysis, but this isn't one of them, and in this instance analysis leads to paralysis. You need to get comfortable with responding immediately, even passionately, to your sense of intuition, instinct, and impulse. You don't need to explain this type of abstract photography to others, you just need to enjoy it yourself, as an artist and creator.

▲ *The key to shooting consistent abstract photography is to heavily rely on instincts, impulses, and intuition. This isn't the time to paint by numbers, this is your opportunity to showcase your photography, in your way, in your style, using your own voice and vision.*

ASSIGNMENT

33

▼ *There are only two real factors for determining whether your neon photograph will be mediocre or masterful: using the right lens and focal length, and shooting under the optimum lighting conditions.*

TIPS

- The darker the skies become, the more challenging it is for the camera to make a correct exposure. It's best to shoot the sky at golden hour or blue hour (see Assignments 16 and 17).

- The iPhone camera will attempt to neutralize the neon color in an effort to provide the correct color balance for the image. During post-processing, you may have to use the Saturation, Vibrancy, or even the Warmth slider adjustments to make it appear more like the actual conditions of the scene.

- Neon signs look fantastic if you can manage to shoot at a low angle, with a puddle or shiny surface reflection in the foreground (see Assignment 25).

LIGHT UP OUR LIVES

Just when you thought the era of neon signs was on its way out, these cult favorites are making a full-steam comeback. These playful, colorful lights were invented in 1910 and popularized and glamorized in the 1930s and 40s. From their humble beginnings, neon signs have long captured the imagination and attention of photographers, videographers, and filmmakers alike. They come in all different shapes, sizes, colors, and personalities. They are at their best and brightest during twilight or dark. The interesting thing about photographing neon signs with your iPhone, especially with the advent of Night mode in iOS 14, is that it is crazy-simple and absurdly fun too.

Obviously, in addition to nailing your correct exposure, the other key is to not try to shoot neon signs during the day (unless indoors), but wait until the golden or blue hours, when the sign itself is contrasted against the early morning or early evening skies. In my opinion, blue hour is the most magical time to shoot neon signs, when the sheer form and color of them take shape and pop against the night skies.

I want you to photograph a single neon sign during this period, in three different ways, using three different focal length lenses. For your first shot, shoot a wide-angle image that shows off the neon sign and puts it in a larger neighborhood context. For your second shot, zoom in with the optical zoom a little and make sure the neon sign occupies at least half of the image frame. Then, for your final shot, get as close to the sign as you possibly can and take a nice, full-frame shot of the sign in its full color glory. Note how your emotional resonance toward the neon subject changes with each cropping and perspective. Which version is your favorite? And why?

iPHONE NOTES

- With iOS 14 and later, Night mode automatically turns on in a low-light environment. It works by taking a series of photos at different exposures to produce a single image.

- A number appears next to the Night mode icon, indicating how long the shot will take.

- In Night mode, you have the option to shoot for one to three seconds while holding the camera in your hand.

- For best results, I would strongly recommend you either place the iPhone on a flat surface or use a tripod to increase stability and exposure clarity.

- When the iPhone camera detects you are using a tripod (or flat surface), you can manually adjust an exposure time of up to 30 seconds.

- You can take Night mode selfies and time-lapse videos with iPhones 12 or later.

ASSIGNMENT
34

TIPS

- If you are not ready to photograph strangers, start out by shooting portraits of your family and friends in a familiar environment.

- The more comfortable your appearance is, the more relaxed your subject will be in the final frame.

- If you make this brief encounter about the subject rather than you and your camera, they will likely be more cooperative.

STRANGER THINGS

Most people are gripped by fear when thinking of taking pictures of strangers on the street. This can be a fear of rejection when people say "no," but it can also be a fear of connection when people say "yes." These fears can be paralyzing and prevent people from ever attempting street portraiture. That's a crying shame.

Take a deep breath and relax. You've got this—it's not as complicated as you might think. As a matter of fact, once you have a couple of positive experiences under your belt, instead of fearing these encounters, you will crave them and have the confidence to look for them. The secret is to make this momentary contact with another person a positive, flattering experience for the both of you. To do this, you'll need to think about your photographic meet-up being less about you and your camera and more about them and their emotions.

I want you to find and head down to an open-air public event where there are people enjoying themselves and casually milling around. Once there, don't be in a rush, take your time. Begin to look for someone that you think has photographic potential. Approach this person with a smile, slowly and respectfully. Make eye contact. Tell them, in your own words, that you are a budding hobbyist photographer, that you find them photographically interesting, and would like to take a quick photo of them. Most people will be flattered that you noticed something about them that caught your eye. Take a dozen photos so that you have a variety to pick from. Repeat this process with other people until you no longer have a fear of asking strangers to take their photo.

iPHONE NOTES

- When using the iPhone's Wide camera, don't get too close to your subject or you will distort their facial features. For the most natural and flattering portraits, stay about an arm's length away.

- It's usually more comfortable to start your photo session with the Wide lens, then as you develop trust and camaraderie with your subject, look to get closer and use a longer focal length with the digital zoom to crop in closer, or by selecting the Telephoto lens, which will provide a far more flattering perspective.

◀ *I did not know any of these people before I took their photos, the time that I had to photograph each was less than a minute, and I will likely never see them again. But all these photographs have an intimate emotional quality. The key to making good portraits is to make your brief session about the model. The heart of true portrait photography is capturing humanity and humility.*

ASSIGNMENT

35

TIPS

• I tend to think that the subjects and scenes that translate best to black and white are the ones that are simple and minimal. No fuss, no muss.

• Be on the lookout for high-contrast scenes with rich and deep blacks.

• Use textures to create eye-catching contrast in a scene.

• The iPhone's black and white filters are Mono, Silvertone, and Noir (see Assignment 18).

FINDING YOUR ANSEL ADAMS

Ansel Adams (1902–84) is generally considered one of the most influential photographers of all time, and that's primarily because of his sharp-focus, large format, black and white images of the American West. Adams's work was one of the things that inspired me to become a photographer, and I've had a love affair with black and white photography my entire career. Black and white is a powerful medium that not only removes the distraction, even fatigue, of color, but it seems to help most viewers to focus on the quintessential elements of the photograph.

The issue for many is whether to shoot in black and white, or shoot in color and convert them in post-processing. I prefer the former because I can see how the final image will look when composing the shot, and enjoy the immediate results of my efforts. However, most people prefer to shoot in color and decide which of the photos they want to convert to black and white in the curating and culling process.

For this assignment, I want you to take a walk for an hour, shooting at least a dozen black and white images on the way of anything that catches your photographic fancy. Take special note of how you feel as you see the images on your screen—do you feel like you are shooting on black and white film? Ask yourself, now that you are shooting in black and white, are you photographing the subjects in the same way as if you were shooting in color? Or is the experience different for you? How different? And do you know why? When you are shooting in black and white, can you see and recognize shape and form more clearly?

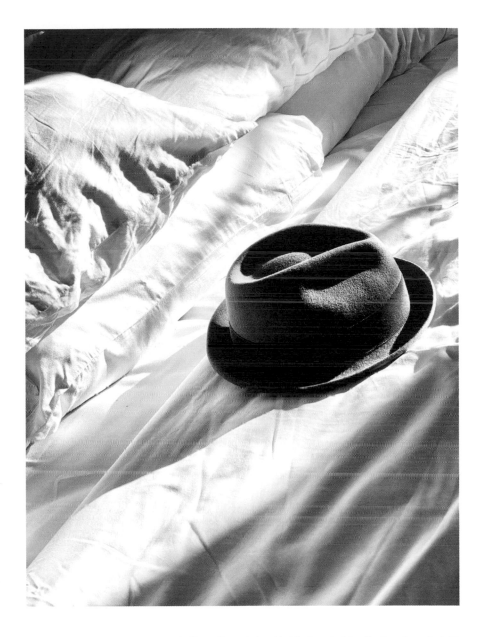

▲ *Sometimes I shoot in black and white. At other times I might turn a color photo into a black and white shot later on. The key for me as to whether to go color or black and white is whether the subject calls for the latter. To be strong and readable, black and white photographs need to be simple, minimal, and graphic.*

ASSIGNMENT

36

▼ *Because of the aspect ratio of panoramic photos, they don't display well on a lot of social media platforms, but don't let that put you off—done well, they can be spectacular.*

TIPS

- Pano mode is designed to be used handheld, without having to resort to a tripod, but some of my best panos were shot slow and steady with the use of a tripod.

- Depending on whether you are right- or left-handed, you can tap the arrow to pan in the opposite direction.

- To pan vertically, rotate the iPhone to landscape orientation (you can also reverse the direction of a vertical pan, too).

- Because these file sizes are large (multiple images stitched together), they can be great for making prints.

- It's best to avoid moving objects in the frame when creating panos.

- Instead of moving your feet, stay in the same position and turn your upper body slowly and swiveling at the hips, while exposing the entire scene.

THE PROCESS

1 Find your way to the Shooting mode bar and select the Pano option.

2 Tap the Shutter button.

3 Pan slowly in the arrow's direction, keeping it on the center line.

4 Tap the Shutter button again when you want to finish the pano.

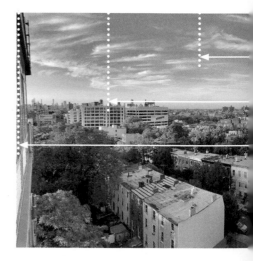

EXPLORING THE WIDE WORLD

Sometimes the built-in lenses that come with the iPhone are simply not wide enough to capture that breathtaking mountain range, beach sunset, or neon skyline in front of you. Enter the iPhone Panorama mode. Pano has been around since the iPhone 5, and it has operated in pretty much the same way in every model since. It gives you a simple guide bar in the middle of the screen to help you take the photo. At its maximum width, it takes up to 63 megapixels of data. The automatic, under-the-hood stitching together of the individual photos isn't always perfect, especially in scenes with a wide dynamic range, but nonetheless, it's still darn remarkable and accurate.

You can also use the Pano mode at less than the maximum width to act as a pseudo wide-angle lens. For example, the Ultra Wide lens gives you a 120° angle of view. The Panorama mode at its full width gives you a 240° angle of view, but you can use less than the full width to achieve the wide-angle lens effect you desire.

This assignment is to get you comfortable with the multiple widths available in Pano mode. I want you to pick out a wide landscape scene that will work as a panorama. Shoot the same scene six different times, each at a different total width, from 120° to 240° angles of view. Now compare the results and decide which one works best for this scene. It should immediately become apparent when viewing the six images how it is possible to use Pano mode to create a super-wide 240° sweeping panorama, or, by using shorter widths along the guide bar, to create different wide-angle interpretations of the same scene.

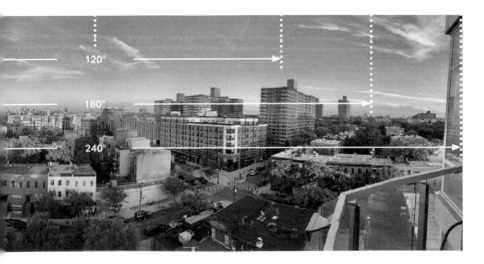

▲ *I tend to shoot in Pano when the Ultra Wide lens with its 120° field of view isn't quite wide enough, such as street scenes.*

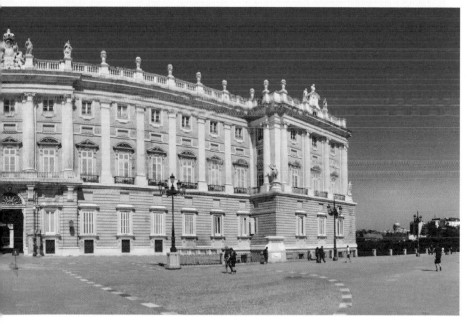

ASSIGNMENT

TIPS

• When using the iPhone camera's Portrait mode, the app lets you know when you're too close or too far away, or when the scene is too dark for Portrait mode.

• In Portrait mode, you can also apply filters, set the timer, and use the True Tone® flash.

• After you take the photo in Portrait mode, you can continue to use the built-in editing features to auto-enhance, rotate, or crop the image, or even remove the Portrait effect altogether.

• Built into the mode is an effects slider that simulates what the background might look like at different f-stops.

DON'T STAY FOCUSED

The amount and degree of background sharpness or blur can make or break a photo. Quite often, especially when shooting people and portraits, you want the viewer's focus and attention to be on the subject and not on the backdrop. So in these circumstances, it can be a good idea to soften and blur any distracting and unwanted background elements in your photos.

With conventional cameras, background focus is controlled by three factors: lens aperture (using a wider aperture creates a softer background); focal length (longer lenses create more pronounced, out-of-focus backgrounds); and the distance from the camera to the subject (getting the camera close to your subject helps create blurred backgrounds).

Unfortunately, both the lens aperture and focal length are fixed on iPhone cameras, giving the end user no control over either. So, through their computational photography efforts, Apple created a depth of field effect that works brilliantly with their Portrait mode. With this, you can apply a depth of field effect that keeps your subject in sharp focus while at the same time creating a beautifully blurred foreground and background. This simulated background blur is called *bokeh*—a Japanese word referring to the aesthetic qualities of the blurred background.

▶ *Portrait mode helps any photographer put full attention on the most important part of the photograph—the subject—and not the background.*

For this assignment, ask a friend to briefly model for you. Take two different photos: one in Photo mode and one in Portrait mode. To use Portrait mode, open the camera app and swipe to Portrait mode. Move farther away from your subject if the app suggests it. When the Depth Effect box turns yellow, take the picture. Compare the two photos. You should see the difference Portrait mode makes by taking the hard edge off the background so it doesn't grab the viewer's attention.

ASSIGNMENT

38

TIPS

- Keep the shoot to no more than two hours (one hour is better).

- Shoot when the light is the most flattering, say two hours before sunset.

- Make sure everyone in the family is on the same page when it comes to clothing, so your group shots look styled.

- I like starting with group shots, then when everyone is warmed up, move on to the individual portraits.

- Take a healthy variety of both formal portraits and informal, candid shots.

THE NEW FAMILY SHOEBOX

When I was growing up, formal family photos were taken only once every few years. These photos were a treasured part of our family history, kept safe in shoeboxes and albums that we would bring out during family get-togethers or reflective moments.

Now, our camera rolls—spread out across multiple devices owned by different members of the family—have replaced the family albums and shoeboxes. These individual camera rolls are more reflective of our personal, rather than collective, life experiences. What we have lost in this rush to document ourselves is the family footprint of our lives together. We seem to have lots of photos of ourselves but not so many of each other. Maybe it's time to change this disproportion and get back to documenting life together, as a family.

Phone cameras are never more than an arm's length away from capturing that perfect communal moment and memory. Every year for my birthday, my family asks me what I might like for a gift, and what I always ask for is a family photo session. Your assignment, even if it isn't your birthday, is to gather the troops—bribe them if you must—and head to a local park for a late afternoon snapshot shooting excursion. I want you to return from this photo-outing with the following types of shots. First, take a group shot, which means you will need to bring a tripod, set your camera on timer, and jump into the final shot. Next, have each member of the family use your iPhone to take their own version of a group selfie. Finally, take individual portraits of each family member—don't come home until you have a beautiful shot of everyone.

▲ *I have been lucky enough to travel and shoot all over the world, but the most treasured photographs I own are of my family. I take candid shots of family events and experiences, but some of my all-time favorite photos of my kids and extended family are directed shots.*

iPHONE NOTES

- Everyone's face is flattered by shooting slightly above eye level. In other words, position your lenses a little above your subject's eye level, and shoot slightly downward. Try to avoid shooting upward at chin level.

- Instead of capturing one single frame at a time, try Burst mode and pick the best peak-action shot from your options.

- If you have shaky or jittery hands, you have the option to trigger your shutter with the volume-up rocker (activate in Settings) or your Apple EarPods® headphones.

- Many people don't realize this, but you can snap photos and record video at the same time. When shooting in video mode, hit the white, on-screen shutter button to simultaneously take a 16:9 aspect ratio photo in addition to the video clip.

- If you want to make sure you're nailing your focus points and not relying completely on the camera to focus for you, make sure you tap on the part of the photo that you want the camera to focus on (see Assignment 1).

TIPS

- Negative space is often a large, plain area of sky, grass, vegetation, or water. But negative space doesn't have to be blank or white space, it's just the space that surrounds and supports the positive space.

- Positive space tends to advance in a photo while negative space tends to recede.

- Shooting directly overhead is a surefire way to graphically deconstruct the shapes and forms in your photographs into positive and negative space.

- If you are finding it difficult to isolate negative space in your photos, try shooting using one of the black and white filters (see Assignment 18).

POSITIVE AND NEGATIVE SPACE

In photography, positive space is the actual subject while negative space is the setting—positive space is the content, negative space is the context. It is easy to understand that positive space is what the viewer will first pay attention to, but positive space also needs an environment, a backdrop, a frame of reference to be understood. This atmosphere or ambiance is negative space.

Negative space has the primary role in your photography to accentuate and highlight the positive space (the subject). Negative space provides room around your main subject area and focal point, giving the viewer's eyes a resting place. On an emotional level, negative space represents calm, peacefulness, isolation, separation, emptiness, and quietness.

For this exercise, I want you to look at your camera roll and select five images that you think best represent positive space and another five images that you think represent negative space. Do you seem to shoot more positive or negative space subjects? Do you know why that is? Are your photos cluttered, or do they have lots of breathing room? Do you tend to fill up every square inch of your photos with objects and elements (positive space)? Or are you more streamlined and minimalistic and give each of your objects and elements in the frame white space (negative space)?

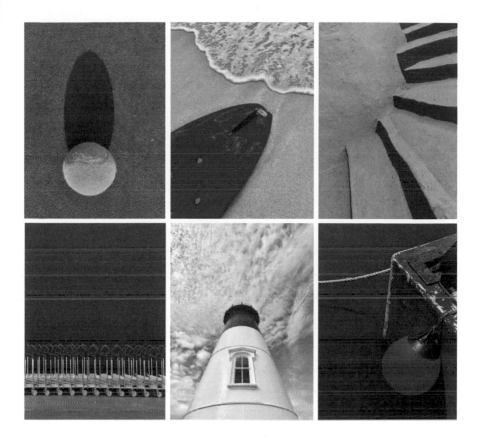

▲ Once I find the subject or scene I want to shoot, I am constantly moving my body, and thus my camera angle, to get the right mix of positive and negative space.

iPHONE NOTES

One of the hidden features on the iPhone is for changing the aspect ratio from the default 4:3 to 16:9. The 16:9 aspect ratio is the default ratio for shooting video, but you can also take photographs in 16:9. The full screen gives you plenty of scope to understand and appreciate the subtleties of positive and negative space in a photograph.

TIPS

- All digital photos, from both conventional and phone cameras, come out a bit bland, aesthetically speaking, and can often use some post-processing help and love.

- Using the slider adjustments to enhance your captures is not cheating.

- If you don't like the adjustment slider values that Auto Enhance has assigned, you can go and further tweak the individual sliders to your taste.

WAVING THE MAGIC WAND

If you are anything like me and the millions of other iPhone photographers who don't enjoy post-processing and would much rather spend the time being out shooting, I have some great news for you. Apple's built-in Auto Enhance function in the Photos app is the perfect place to begin your no-hassle editing journey. With a single tap of the magic wand, all the hard work is done automatically, meaning you can approach the tedious processing of photo editing with speed and comfort.

Auto Enhance is designed to optimize any photo in an intelligent, computational way, analyzing and adjusting instantaneously and appropriately. There is no longer a need to learn laborious editing and slider algorithms if you don't want to, or if that's not your thing. One touch and you're good to go, like magic. Next!

It's very cool. With iOS 13, Auto Enhance was changed from a simple on/off button to a slider, and moving it up or down adjusts every relevant slider value, from exposure and brightness to saturation and vibrance. This should give you the perfect blend and mix of adjustments and produce a photo with a professional look and feel, without the hassle and headache of editing, pixel by pixel.

Because seeing is believing, I want you to pick ten photos from your camera rolls that could use a bit of post-processing love. Now, using the Photos app and the Auto Enhance feature, apply the magic wand to each. Voilà. Unbelievable, right?

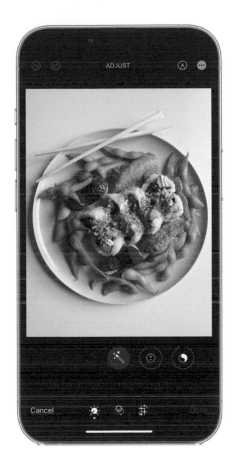
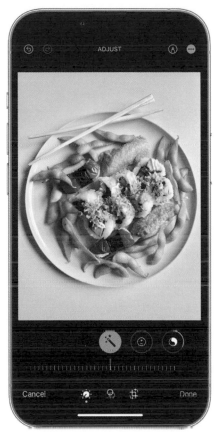

▲ *If you're not comfortable using post-processing apps, then using Auto Enhance is your one-touch key to awesomeness. It couldn't be any faster or easier. One touch, done, next.*

PRO TIPS

I make a pretty big deal about taking a purist's approach to my iPhone photography and wanting my final images to look like photographs, not illustrations. This means spending more time in the field shooting than time behind a screen editing. Auto Enhance is one of my best friends.

Because I don't especially enjoy tedious image editing and because I use the Auto Enhance feature so much and so often, I usually consider it the starting point for most of my editing. If I like what I see, I move on. If I don't and I want to tweak further, I have this option as well, via the adjustment slider tray.

TIPS

- You can take Burst mode photos with both the rear- and front-facing cameras.

- You cannot toggle on or off the Burst mode on your iPhone. It is always on by default.

- Because Burst mode shoots at such amazing speed (ten frames per second), there is a good chance that you are going to get that perfect expression or action shot in at least one of your selected photos.

▶ *I set up my iPhone on a mini tripod at pool level and used the camera's Burst mode to record everyone leaping into the pool.*

THE DECISIVE MOMENT

Henri Cartier-Bresson (1908–2004) was a French humanist photographer and a master of street and candid photography. He was well known for coining the phrase "the decisive moment." You could probably make a case for a photograph's "decisive moment" being when the visual, emotional, and psychological elements all come together in a single frame.

But how exactly do we capture this key moment given that life races by at breakneck speed? Enter Burst mode—a nifty iPhone feature that allows you to create high-resolution photos of moving subjects and objects at ten frames per second. Think of Burst mode like an old-fashioned camera motor drive or power winder. Burst mode is a game changer for when you want to take multiple photos, so you have a full selection to choose from.

You can execute this next assignment with friends, a relative, or even a beloved pet. Sit in the backyard on a bright, sunny day. Have your subject(s) run past your camera, and as they're running past, shoot the scene using Burst mode. Were you able to capture your own decisive moment? Did you get that peak action shot you wanted? Can you imagine how difficult this same shot would be to get without the aid of Burst mode?

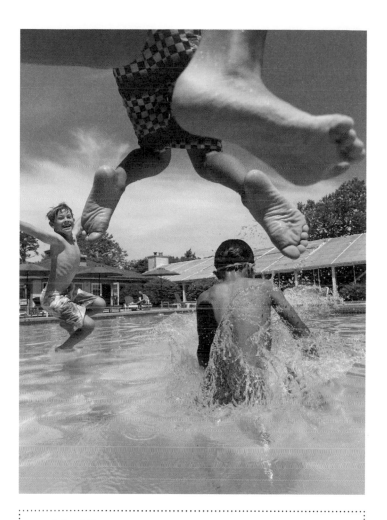

PROCESS

1 To use Burst mode on recent iPhone models, swipe the Shutter button to the left. If you're using an iPhone X or older, hold the button instead. Lift your finger when you want to stop taking shots.

2 The Photos app automatically puts them in a Bursts album, which you will find along with the rest of your camera roll albums.

3 To select individual photos, tap the Burst thumbnail, then choose Select from the menu bar.

4 While editing, you have the option of saving a single photo, multiple photos, or the entire Burst sequence.

ASSIGNMENT

42

TIPS

- This high-key grayscale effect is perfect for when you want to quickly knock out the background and bring focused attention to the subject and nothing else.

- High-Key Light Mono is one of the options when you are in Portrait mode.

WHITE AS SNOW

Have you ever wondered how people take striking portraits on a white background? With what I'm about to share, you can take studio-quality portraits without ever setting foot in a studio. With 2019's iOS 13 release, Apple introduced a sixth Portrait lighting effect: High-Key Light Mono. It doesn't always work, but when it does, it's absolutely brilliant. Found within Portrait mode, the effect creates a grayscale subject on a white background. Sometimes it looks a bit fake and contrived. But at other times it looks like you took the photo in an expensive studio environment.

To take advantage of this effect, you need an iPhone model from 2018 or later, such as an iPhone XS or XR. You can take a photo with the High-Key Light Mono portrait lighting effect and enjoy a real-time preview in the Camera app, or you can apply it to a photo stored in your camera roll if it was previously shot in Portrait mode.

For this assignment, I want you to shoot four different portraits of four different people using Portrait mode. Keep the backgrounds as minimal and uncluttered as possible. During the editing process, apply the High-Key Light Mono effect to each, using the adjuster slider to control the intensity of the desired effect. Which photos worked well with the effect, and which didn't? Is there anything you can control that affects the quality?

PRO TIPS

When photographers geek out about lighting ratios and styles, they frame this technical discussion around high-key and low-key lighting. High-key lighting is light and bright and low-key lighting is dark and moody. High-key shots lack dark tones and are generally thought of as positive, cheerful, and upbeat. Low-key images, on the other hand, are darkly lit and high in contrast. Whether they recognize it or not, any photographer will naturally lean toward one of these aesthetic lighting styles and their work will be predominately "light" or "dark."

◀ *High-Key Light Mono effect works best with backgrounds that are simple and lean toward monochrome.*

ASSIGNMENT
43

TIPS

- When shooting indoors in low or dim light, be as steady as possible for each shutter press. Make your body a human tripod: tuck your elbows into your body and then exhale while triggering your shutter.

- Don't even think about busting out a real tripod in the store—not cool!

- Use the Wide (main) camera as it is always going to offer the widest aperture.

- Don't forget the cardinal rule of exposure: "Tap to focus, drag to brighten."

▼ *What is super cool is that as you get used to seeing and shooting common objects in uncommon styles, you will rediscover the freedom to focus on what brought you to photography in the first place—creating art!*

UNCOMMONLY COMMON

What exactly is it about vintage memorabilia that has such a strong hold on our human psyche? Is it the desire to return to a slower, gentler, safer, more authentic page in history? Or is it maybe because we too are—at some innate level—old, dusty, and imperfect that we relate to that which we see, claim, and purchase?

I don't honestly know the answer, but I do know that I could spend hours, even days, wandering around antique stores, thrift shops, and flea markets, photographing common objects in an uncommon style. I find these stores so fascinating to photograph in. A really interesting nuance of shooting antique subject matter is that so many of these seemingly ordinary objects are teeming with stories, both real and imagined. They seem to breathe, and they invite our participation. Just maybe, it's these stories that provide the fuel and fertilizer for intrigue and exploration. All I know for sure is that these humble stores are custodians of time and moments. As such, they require, even demand, our respect and photographic allegiance.

Pick a local store in your neck of the woods and introduce yourself to the owner. Ask, respectfully and politely, if you may have permission to do some casual photography inside the store. Make it crystal clear that you will not interfere with store operations or paying customers. Offer to freely share your photos with the store if they would like copies. Once you get this introductory stuff out of the way, I want you to find and photograph eight objects or mini-scenes in the store that somehow tell eight different stories of your childhood. Do your very best to capture these common objects with uncommon styles.

iPHONE NOTES

- The iPhone camera is optimized for bright, outdoor light. My suggestion for shooting inside under artificial light is simply to slow down your creative process. Take your time and be more deliberative and selective.

- When shooting indoors, it's important to remember that the Wide (main) camera, with its 1× lens, is going to be your highest-quality option for shooting tack-sharp photos. I tend not to use the Telephoto lenses indoors.

- Don't labor over the white balance of your indoor photos, as the tiny camera sensor will struggle with conflicting color temperatures from different light sources. Be content to fix it in post-production.

ASSIGNMENT

44

NO STRINGS ATTACHED

While the range of focal lengths offered by the different lenses in your iPhone will cover any normal shot you may want to take, there will be special occasions when you want a certain look and feel outside these focal lengths. This is where conversion lenses—also called attachment lenses, clip-on lenses, add-on lenses, and mobile lenses—come into the picture.

The most important thing to know about using attachment lenses with your iPhone is that these relatively inexpensive lenses do not generally improve overall image quality. What they do change—often quite drastically—is the camera's angle of view.

Two of the most popular are fisheye lenses and anamorphic lenses. Fisheye lenses have a field of view of 150–180°, depending on the model. The widest field of view you can get with your built-in Ultra Wide iPhone lens is 120°. Anamorphic lenses are designed with mobile filmmakers in mind. On the iPhone's cameras, you'll normally film at a 16:9 aspect ratio, while an anamorphic lens allows you to shoot at a 2.39:1 aspect ratio, making it ideal for widescreen viewing.

For this assignment, I want you to buy or borrow either a fisheye or anamorphic lens for your iPhone camera, so that you can get a first-hand experience of what these fields of view look like, compared to the lenses that are integrated into each iPhone camera.

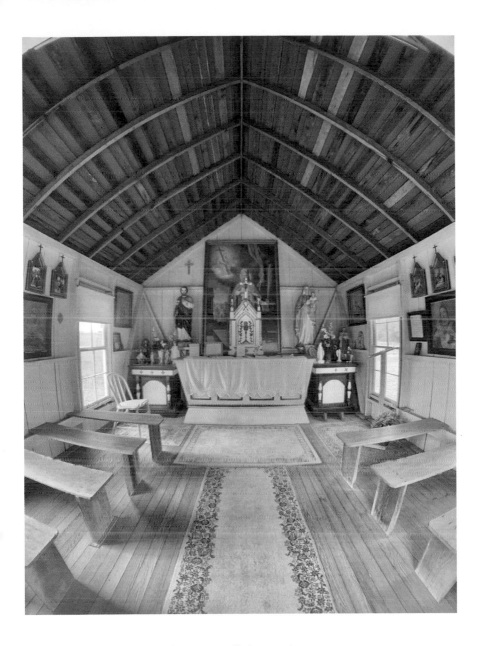

▲ *While for everyday photography you are unlikely to need an attachment lens, there will always be special occasions where the creative use of an anamorphic or fisheye lens can bring a new dimension to an otherwise familiar scene.*

TIPS

- I tend to use the Telephoto lens when shooting pure color. Its narrow field of view is perfect for getting close to your subject and minimizing distracting elements.

- Color in indirect, soft light tends to be flat and muted. Color in direct, hard light tends to be contrasty and textural.

- To minimize color fatigue (too many colors in the same frame), try to limit your hues to one or two colors in a single photograph.

▶ *Many photographers try to include too many conflicting colors in the same frame. Keep it to one or two strong colors.*

OUT OF THE BLUE

Whether you recognize this fact or not, it's safe to say that the colors in your photographs are probably the greatest determinative factor in the way you and others feel about the pictures you take. Color in photography is part science, part art, part culture, part bias, and part style. Color does a lot of things for your photographs, but most importantly it evokes emotions, feelings, and moods.

For most of us when we are starting out in photography, color is an afterthought to the subjects we are shooting. In other words, we see the subject first, then accept and work with the color palette that the subject offers up to our camera. But what if we could learn to see color in a new light? What if we could begin to see color before we even see our subject? Wouldn't this be fun and exciting?

For this assignment, put on your subject-agnostic glasses—for this exercise, color is content. I want you to take a total of seven photos, each of them featuring a different color. And I want you to think about, or at least be aware of, your emotional frame of mind while you are shooting each color. Here's a list of positive emotions, generally attached to each color, to prepare you for what you might experience:

- **Red**: energy, passion, love, excitement, fire, blood, and romance.
- **Orange**: warmth, happiness, enthusiasm.
- **Yellow**: cheerfulness, happiness, frankness, creativity.
- **Green**: calm, naturalistic, balance, growth, forwardness.
- **Purple**: spirituality, royalty, mystery, luxury.
- **White**: purity, innocence, novelty, sterility.
- **Black**: elegance, sophistication, power, formality, magic.

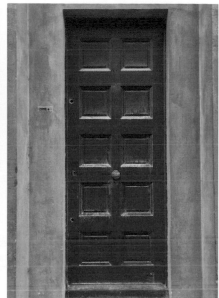

▲ One of the most crucial things about post processing color is to know when to stop. Less is more.

PRO TIPS

I used to think of color in photography as an element that reflected our photographic state-of-mind at the time of capture. In other words, the colors we choose to include in a composition reflect how we are feeling on the inside. However, more recently I've come to see color as having a less passive and more active role. In other words, color in photography doesn't just reflect, it also directs our internal world of changing and morphing emotions, moods, and sentiments. That's an awesome thing

iPHONE NOTES

With each iteration of new iPhone cameras, the internal color processing gets better and better. Apple has always made a significant effort to make sure that the colors you see in your images are as close as possible to the colors you see with your eyes. This separates them from the competition, which tends to overprocess and oversaturate the photos you view on the phone screen. Apple keeps the files more natural and neutral in color.

ASSIGNMENT

46

TIPS

• Make sure you are on public and not private property.

• Don't worry about getting too close. But get close enough so that you can recognize people's faces, emotions, and actions.

• Choose your background carefully, so that it's not too cluttered or distracting.

• A very common tactic among iPhone street photographers is to plug in your EarPods and use the volume-up rocker on them to discreetly trigger your shutter.

TAKING IT TO THE STREET

Street photography is a genre that records everyday life in public spaces. It is probably one of today's most popular categories of smartphone photography, and for good reason, too. The sheer public and democratic nature of these urban settings enable and empower photographers to take candid photographs of people, often without their knowledge. One of the great things about street photography with an iPhone camera is that due to its size and ubiquity, you tend to blend in with the crowd. This makes it easier for you to go about taking candid photographs.

The lion's share of my own street photography is permission-based (see Assignments 19 and 34)—I have never been that comfortable shooting people who are unaware of my presence or camera. But that said, many street photographers would passionately argue that asking permission robs the scene of its authenticity and believability. Regardless, your success as a street photographer will have less to do with your camera and more to do with your diplomacy, kindness, humility, patience, and sense of instinct.

For this assignment, I want you to go through the process of photographing people on the streets who are unaware of what you are doing. Head to a busy, downtown street corner, find a vantage point that you like, and for 30 minutes just watch the ebb and flow of life go by. Now, become a part of the crowd. Be a participant in the street life and not just an observer. Shoot what you see and feel. Unleash your inner journalist and click away. Shooting discreetly, without asking for permission, can provide a lovely sense of surprise and realism to your images.

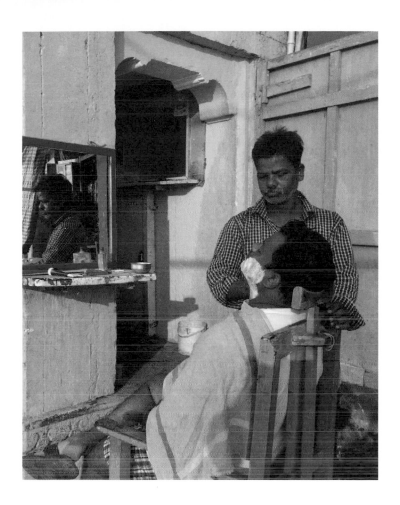

▲ *I tend to shoot permission-based rather than candid street photography, but the latter approach can give you more spontaneous and natural results than arranged photography.*

PRO TIPS

There are two pieces of advice that I can give you for raising your street photography game. Firstly, don't be stingy about the number of pictures you take. Shoot widely and liberally. Get a good selection of angles, perspectives, and points of view. Secondly, when I'm shooting fast-paced action on the street, I often shoot in Burst mode (ten frames per second).

ASSIGNMENT
47
—

TIPS

- Front lighting is the easiest and least dramatic of the lighting directions. In portraiture, front light is forgiving with facial blemishes and imperfections.

- Side lighting is more dramatic, moody, and mysterious and it reveals texture. It also separates the subject nicely from the background.

- Backlighting is best for silhouettes. The resulting images will be more focused on body posture than facial expression.

LOOK ON THE BRIGHT SIDE

For photographers, the direction of light on their subject has a huge effect on how three-dimensional the subject appears to the viewer. Unfortunately, in the real world, we have little-to-no control over the direction of lighting on our subjects.

Front lighting emanates from behind the camera onto the subject. It tends to flatten the subject and create a shadowless look and feel.

Side lighting comes from a 45–90° angle to the left or right of your camera, or less commonly diagonally from your camera over your subject. It brings out texture and form, it can create shadow and mood, and it provides contrast and depth. It can be equally effective with any subject matter—people, places, and things.

Backlighting is the most difficult light to compose and expose. It comes from behind the subject, pointing at the camera. Strong backlight generally results in a silhouette.

This assignment is probably best done with a person as your subject. I want you to photograph your model in bright, outdoor sunshine (not in the shade). Shoot three separate photographs with different lighting effects: front lighting, side lighting, and backlighting. Compare the three photos. With the side-lit shot, the light hits the face and helps create a flattering "roundness" to the final image. In contrast, the other two portraits are likely to be flat and characterless.

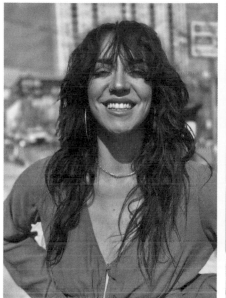

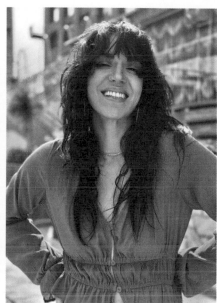

▲ *Front lighting minimizes shadows and is often the most flattering option for portraits. Backlighting can provide a natural "rim light." You have to be careful with side lighting as it can accentuate textures and shadows.*

iPHONE NOTES

When you are shooting an outdoor portrait with strong side lighting, you need to make sure that the shaded part of the face doesn't fool your in-camera exposure meter. In these circumstances, tap and hold on to the bright part of the face until the AE/AF Lock message appears, which means the exposure is locked. Now use the Brightness slider to find a balance between the shadow and highlight areas, then take the photo as you normally would. Locking your exposure on the highlight area of the photograph will ensure that the side in shadow remains appreciably darker and true to form.

ASSIGNMENT

48

TIPS

- The default iPhone camera mode is Auto. In it, you are letting the camera decide what your creative intentions are for focus points and exposure. This assignment is probably the perfect environment to go "Auto" and shoot as quickly and intuitively as possible.

- Giving your subject something to do— holding a glass or hugging a friend—often relaxes their facial muscles and hands and makes the photographs look more natural and less posed.

- For group shots, I tend to use the Wide (main) camera, which is equivalent to a focal length of 24mm to 26mm depending on the iPhone model.

- For more intimate, close-up portraits, within the group setting, I would probably switch to the Telephoto lens.

iPHONE NOTES

- Live Photos is an iPhone camera feature that brings movement in your photos to life. When your Camera app is open and Live Photos is on, your phone is constantly taking and then deleting photos in the background. This means that when you take a photograph, your iPhone saves what happened in the 1.5 seconds before as well as after you took the picture. It's perfect for lifestyle photography as you get both a photo and a three-second, fifteen frames-per-second video with sound.

- Face detection is built into iPhones, which is awesome for people and lifestyle photography. The iPhone will face detect and properly autofocus on up to ten people in a scene, which is great for group shots. The newer iPhone models also have cool blink and smile detection to help you capture that perfect shot.

▶ *Most of these images were shot while seated at table level using nothing more than the Wide (main) camera/lens combo. When you are shooting these types of celebrations, it's best to get a healthy dose of both candid and staged shots.*

LIFE. CAMERA. ACTION

Lifestyle photography is the art of shooting real people in real situations, expressing real emotions. It isn't staged or posed—it's shooting life as it happens, whether good, bad, or indifferent. It also tends to be aspirational in nature—it is not just the casual recording of the beautiful messes that are our daily lives, but also capturing our hopes and dreams of betterment, improvement, idealism, ambition, and expectation. It is the perfect blend of documentary journalism and portraiture.

Your job here is to gather a group of your friends, perhaps during happy hour, and shoot the whole group experience without posing a single shot. Pay special attention to capturing genuine emotions and expressions. Look for intimate interactions between group members. Shoot with different lenses. Vary your angles and perspectives. Pay attention to what's in the background. Look for close-ups that don't involve people. Shoot in direct light as well as open shade. Try to come up with at least twelve shots that you could use to supply illustrations for a magazine spread on the topic of intimacy and friendships.

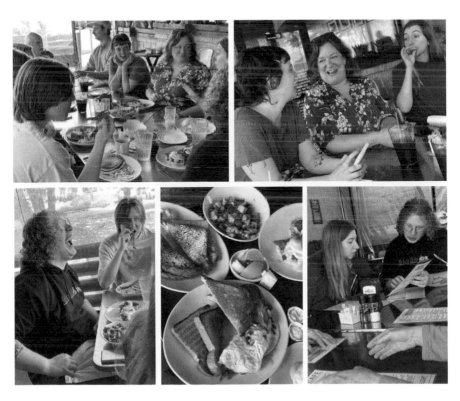

ASSIGNMENT
49

TIPS

- One type of framing is *repoussoir*, which means "to push back," and involves using objects in the foreground to lead the eye into the rest of the composition.

- Wide-open spaces, full of empty skies, can be a bit boring. Look for low-hanging tree branches and other natural vegetation to enclose and encase your main subject.

- A frame could easily go around all four edges, or it might be just off to the side.

- All "rules" of composition are more like gentle guidelines to follow rather than hard and fast laws that can't be broken. But that said, you need to learn the rule to know how to break it.

▶ *The rule of framing is a remarkably effective compositional tool to focus attention on the subject.*

THE PERFECT FRAME OF MIND

The goal of every photographer is to focus the viewer's attention on the primary, and sometimes secondary, subject matter in a photo. One way to do this is through framing, which means using elements within the scene to draw attention to the main subject. Done well, framing can add both pictorial interest and depth.

Framing is a fantastic storytelling technique to use in a photograph because it invites participation and engagement. Frames are also a great way to obscure or camouflage busy or bland background events.

I want you to illustrate a frame within the frame. The frame in your photograph can be natural, such as tree branches or the mouth of a cave, or manufactured, such as a doorway, window, or the structure of a bridge. Keep the frame secondary so that it provides a simple resting spot and anchor for the viewer's eyes before they move to the primary subject matter.

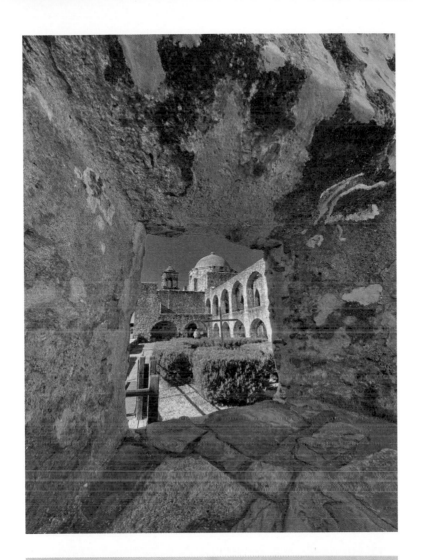

PRO TIP

Any camera in automatic mode won't know what your creative intentions are, and it won't know whether you want to focus on the foreground, mid-ground, background, or all planes. You must tell the camera where to focus. This is especially true when applying the principle of framing to your primary subject. When you have a strong and pronounced foreground element that is not on the same plane of focus as your main subject, you will want to manually "tap to focus" on your main subject so the foreground frame is soft and slightly out-of-focus.

ASSIGNMENT
50

▼ *Lines in a photograph visually affect the viewer's mood, and along with color they are responsible for triggering our emotional response to an image.*

TIPS

- One of the most important values of lines in photography is that they can add balance to a composition.

- Lead-in lines draw on the brain's natural inclination to find patterns, structure, and a sense of visual hierarchy and organization in compositions.

- One of the key elements in exaggerating lines in a photograph is to intentionally change your camera position related to the subject (low, eye level, or high).

- Quite often, pronounced lines are created with the Ultra Wide lens.

- It's not enough to shoot lines for lines' sake. They should ultimately point or lead to the main subject—if they point away from the subject, they will lead the viewer's eyes outside the frame.

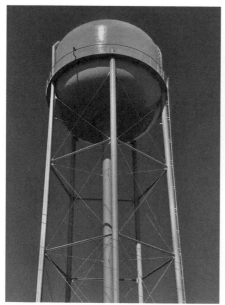

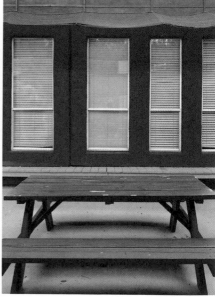

THE BOTTOM LINE

When we look at photos, our eyes are naturally drawn to lines. These lines can be obvious or subtle, physical or implied. Lines provide an organic path through the image for viewers to understand and consume the content. How you use the line is a personal choice—you can position various focal points along a line, or just focus on the end of the line that the eye will land on. Lines are a powerful tool in composition and fun to look at and admire. But they are even more powerful when they serve to direct a viewer's gaze and attention to the main focal point of the image. Becoming a master of lines is becoming a master of composition and design.

Lines can be of any type, and each can be used to enhance a photo's composition. They can be formed by almost anything: shorelines, trees, rivers, roads, railroad tracks, buildings, stairwells, power lines, the list is almost endless.

For this assignment, I want you to select five subjects for each of the following major line categories, which will be best enhanced by the qualities of the different line types:

- **Vertical**: power, strength, energy.
- **Horizontal**: calmness, quiet, steadiness, tranquility, peaceful, restful.
- **Diagonal**: movement, motion, restlessness, force, action.
- **Curved**: sensuality, beauty.

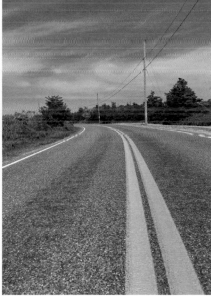

ASSIGNMENT

51

TIPS

- The iPhone's LED flash can be useful as an outdoor fill light when shooting strongly backlit subjects.

- The LED flash can make some shots taken at blue hour look more stylized and edgy.

- The LED flash is meant to be used when the subject is under two feet (0.6m) away.

PRO TIPS

As another option to using the LED flash, try shooting your subject with the flashlight from two separate iPhones. Your camera's flash would be the on-camera light, while your friend's would act like an off-camera light.

iPHONE NOTES

The iPhone 14 Pro and Pro Max feature an updated True Tone flash, with nine LEDs that in certain conditions can be up to two times brighter than previous generations. This gives me hope that they are continuing to improve the overall light quality of the LED flash.

QUICK AS A FLASH

I'm not really a big fan of the iPhone's flash as a primary light source for photography, but even poor light is sometimes better than no light at all. The problem is that while a large light source close to the subject produces soft, flattering, wraparound light, a tiny light source at the same distance produces harsh and unflattering light. Unfortunately, the iPhone LED flash is a tiny light source, but the recent improvements in iPhone's Night mode make use of the flash less necessary. Therefore, the iPhone's flash should be used only sparingly. As an alternative to the LED flash, I find the iPhone's flashlight, accessed via the Control Center panel, to be a slightly more flattering constant light source.

Your assignment will be to compare the iPhone flashlight and the iPhone LED flash. Find an object from around the house, and in the evening, shoot it at table level in relative darkness. Shoot the object first with the iPhone flashlight. Then shoot the object again with the iPhone LED flash. Which one looks the best?

▶ I tend to prefer the look and feel of the flashlight over the LED flash, but it does depend on the subject matter. The top photo shows my vintage camera collection in complete darkness illuminated by the flash, while the bottom photo shows the same scene lit by the flashlight. Which do you prefer in this instance?

ASSIGNMENT
52

TIPS

- If your iPhone has a Telephoto camera, shoot your assignment using the 2×, 2.5×, or 3× zoom, depending on the model.

- Try shooting the scene in Portrait mode so that you can blur out the background to bring attention to the objects.

- The rule of odds is more of a gentle guideline than a hard and fast rule. When I am faced with a scene that has an even number of elements, I ask myself whether the composition would be improved by adding or subtracting an element to make an uneven number.

ODDS-ON FAVORITE

The rule of odds is a simple guideline to improve the readability and engagement of a particular photograph. It suggests that an odd number of subjects and objects in a photograph is more pleasing to view than an even number, so three or five objects would be more appealing than four.

It makes perfect sense to me because an odd number of elements in any piece of art tends to be more off-balance and asymmetrical in nature, and more enjoyable to gaze at. Not surprisingly, long before I had ever even heard of this compositional guideline, I gravitated toward uneven, lopsided elements in my photographs. It just felt right. To give an example of using the rule of odds with three items, you could place one as the main subject in the frame, with the other two objects playing a supporting role. Your eyes will fall to the middle of your arrangement, thus giving your composition a natural focal point. This rule of odds works with anything—people, places, things.

For this assignment, line up a row of photogenic objects. In one of the photos, include an even number of items. In the second photo, include an odd number. Without sharing the back story to this assignment, share your photos, odd and even, with one other person. And ask them to pick their favorite. What do they say?

▲ *The rule of odds works best with between one and seven objects, such as this scene of three colorful old rowboats.*

INDEX

First published 2023 by
Ammonite Press
an imprint of Guild of Master Craftsman Publications Ltd
Castle Place, 166 High Street, Lewes, East Sussex, BN7 1XU,
United Kingdom

This book is written, produced and published by the Guild of Master
Craftsman Publications Limited. The contents of this book has not been
authorised or approved by Apple Inc.

Apple, iPhone, AirDrop, Deep Fusion, EarPods, Live Photos, ProRAW,
and True Tone are trademarks of Apple Inc., registered in the US and other
countries and regions. IOS is a trademark or registered trademark of Cisco
in the US and other countries.

ISBN 978-1-78145-477-0

The publishers and author can accept no legal responsibility for any
consequences arising from the application of information, advice,
or instructions given in this publication.

A catalog record for this book is available from the British Library.

Publisher: Jonathan Bailey
Production Director: Jim Bulley
Design Manager: Robin Shields
Senior Project Editor: Tom Kitch
Editor: Daniel Lezano

Color reproduction by GMC Reprographics
Printed and bound in China

How was the book?
Please post your
feedback and photos:
#52AssignmentsiPhone

AMMONITE
PRESS

ammonitepress.com

FSC
www.fsc.org
MIX
Paper | Supporting
responsible forestry
FSC® C144853